PAINTING BOATS
& HARBOURS

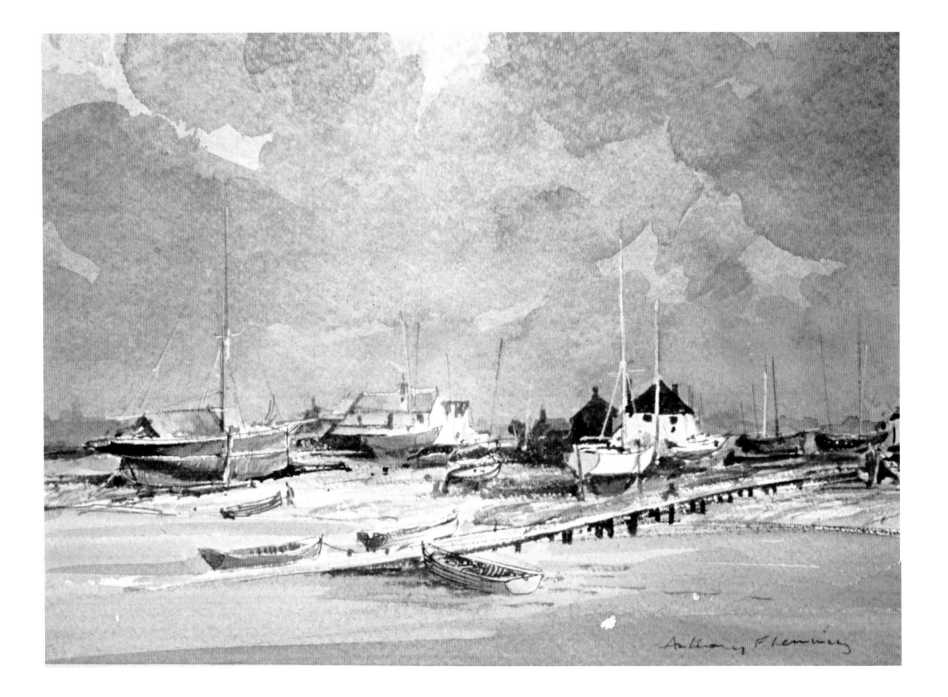

Anthony Flemming

PAINTING BOATS & HARBOURS

Anthony Flemming

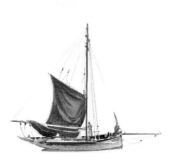

A&C Black Publishers • London

First published in Great Britain 2006

A&C Black Publishers Ltd
38 Soho Square, London, W1D 3HB
www.acblack.com

Designed by Jo Tapper
Copyedited by Julian Beecroft
Proofread by Lucy Hawkes
Project Manager: Susan Kelly
Editorial Assistant: Sophie Page

Printed and bound in Singapore

This book is produced using paper that is made from wood grown in managed, sustainable forests. It is natural,
renewable and recyclable. The logging and manufacturing processes conform to the environmental regulations of
the country of origin.

Front cover illustration: Thames Barge Approaching Greenwich. *Watercolour. 10 × 15 in. / 25 × 38 cm*
Page 2: Waterfront, Burnham. *Watercolour. 8 × 10 in. / 20 × 25 cm*

CONTENTS

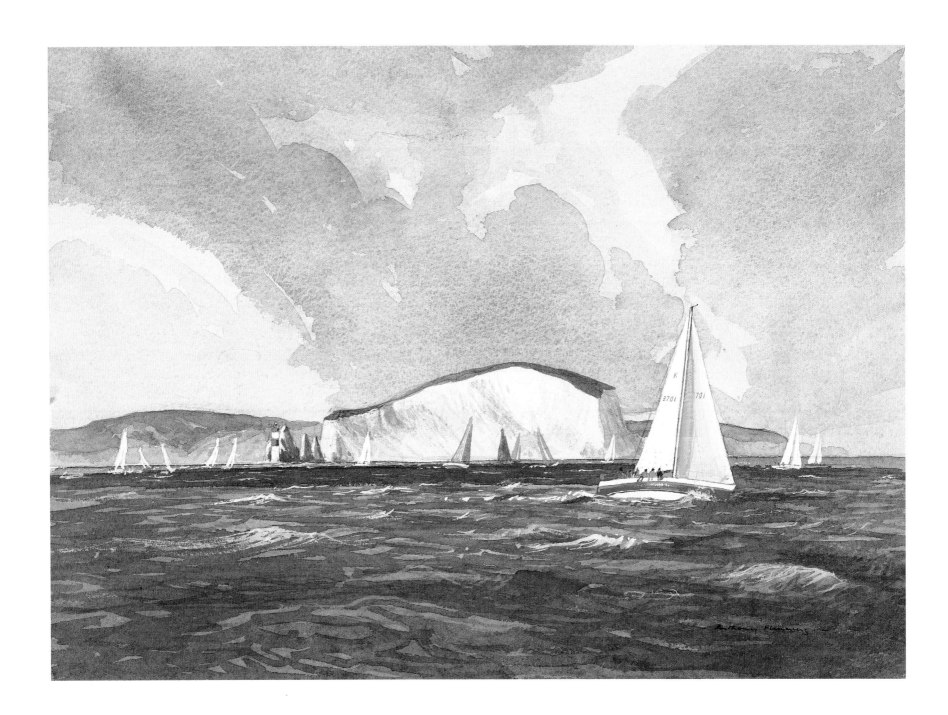

INTRODUCTION

By chance, I find myself in the fortunate situation of being both an experienced sailor and a practising artist. I have learned how to peel a spinnaker in the Fastnet race, and can lay a graduated watercolour wash. As a sailor I have been privileged to experience moods of nature not available to my land-bound artist colleagues. Yet I have also been astounded that some of the crew aboard a racing yacht, or a Thames barge, seem oblivious to the wonder of the visual spectacle all around them.

In this book I will attempt to point out to the sailors how to view and capture some of the images they are privileged to see. At the same time I will point out to my artist friends some of the common mistakes we make: for example, mistakes made in representing rigging; the difference between standing and running rigging; and why some modern yachts have either striped or transparent sails.

The sailors amongst you will know that the sprit on a Thames barge is always to starboard and the spinnaker sheets always go outside the standing rigging. For an artist to make mistakes in rendering the structure of craft will invite derision from those in the know. Yet there is a balance to be struck in producing a painting, between correctness and the overall mood of the scene. Consider Turner's painting *The Fighting Temeraire*. Here the artist has merely hinted at the complexity of the rigging of that great ship. Had he drawn in every piece of rigging, every block and stanchion, the picture would lose so much of its power.

Opposite: Yachts Passing the Needles – Start of the Fastnet Race.
Watercolour. 18 X 20 in./46 X 50 cm.

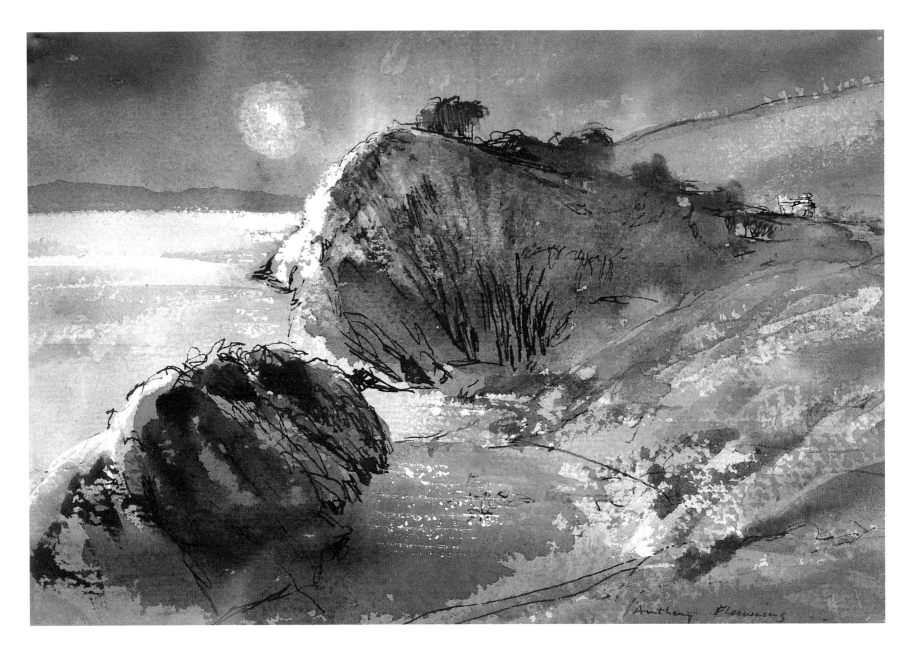

Setting Sun over Dorset Cove. *Watercolour. 8 × 10 in./20 × 25 cm.*

PREFACE

Watercolour is the preferred medium for most painters when painting on the spot. This may seem a little strange, given the inherent difficulties of the medium: a mistake in watercolour is difficult to rectify compared with oil paint. But there may be several reasons why someone chooses watercolour. For instance, many people simply cannot stand the smell of oil paint. Also, with oils the finished work remains wet and sticky, and the palette and brushes must be cleaned. Watercolour, on the other hand, does not smell, the finished work will be dry in a few minutes, and the equipment can be lighter and more compact.

Throughout this book I will concentrate on the use of watercolour for the gathering of information. You will notice, however, the inclusion of numerous oil paintings. In general, these oils were made in the studio from sketches and studies made on the spot.

As a young student I was privileged to meet the artist Norman Wilkinson. One of the gems of wisdom he passed on to me was, 'If you are going to produce a finished oil painting, make all your studies in watercolour.' Another was, 'For a watercolour make oil sketches!' I keep hearing this obviously well-meaning advice in the back of my mind, but I seem never to have followed it. Perhaps I have been missing something.

As a member of the Wapping Group of Artists I have also been privileged to observe how different fellow painters will choose their view. Given that we are all at the same location, one will make a panorama, while another will focus on a detail. One will take the vast expanse of land, sea and sky, another that pony grazing on the bank over there. This diversity serves to enliven the group's annual exhibition.

In contrast, on those occasions when I have tutored groups outdoors, I have been surprised to see how many less experienced painters will attempt a view that is far too complicated. This will, so often, give them a really hard time.

This latter problem brings to mind a piece of advice given to me by the artist Rowland Hilder. *'You get paid for what you leave out.'* This advice I do attempt to follow.

1. GETTING STARTED

Getting started is perhaps the most difficult part for so many aspiring artists. That plain sheet of paper can be quite daunting. 'What if I don't get it right, I will have ruined the paper.' 'I can't draw boats to save my life.' 'My figures never look anything like people.' All these worries and many more conspire to prompt so many to abandon even attempting to capture a scene or object on paper.

The fear of that virgin paper is the easiest one to overcome. Buy a cheap school exercise book, a pencil and perhaps a black ballpoint pen. Scribble away on page after page. Draw anything: the cat, the chair or the house. Attempt some shading with the pencil. Attempt straight lines without a ruler and even some curves. These doodles are the equivalent to the pianist's five-finger exercises. Even on the spot this cheap exercise book can be the place to rough out the scene before attempting a more finished drawing or painting. Above all, have fun. Later on one can abandon the cheap throwaway exercise book in favour of a sketchbook. The sketchbook will become the place where notes are collected: notes of interesting details, as well as those thumbnail sketches of composition.

Painting can be quite a lonely occupation. Even with the best of intentions, it is all too easy to put off the trip to that lovely local harbour. One way of overcoming this inertia is to arrange to make the trip with a like-minded person. This way the obligation to one another will ensure the outing takes place. The driving can be shared and the companionship will make the experience more rewarding.

Joining a local art group is a great way to meet up with these like-minded people. Most groups consist of enthusiasts of varying ability, drawn together for mutual encouragement and companionship. Problems are discussed and frequently there are demonstrations or workshops where a professional artist will give advice and help. But, if you are determined that marine subjects are the thing you are after, there are few, if any, groups that specialise in this field.

Here the sailor has a distinct advantage. He will be off to the sea at every opportunity. Whether he is a racer or a cruiser, he will have a surfeit of subject matter arrayed before him. The quiet anchorage or busy marina each offer challenges to be captured in paint.

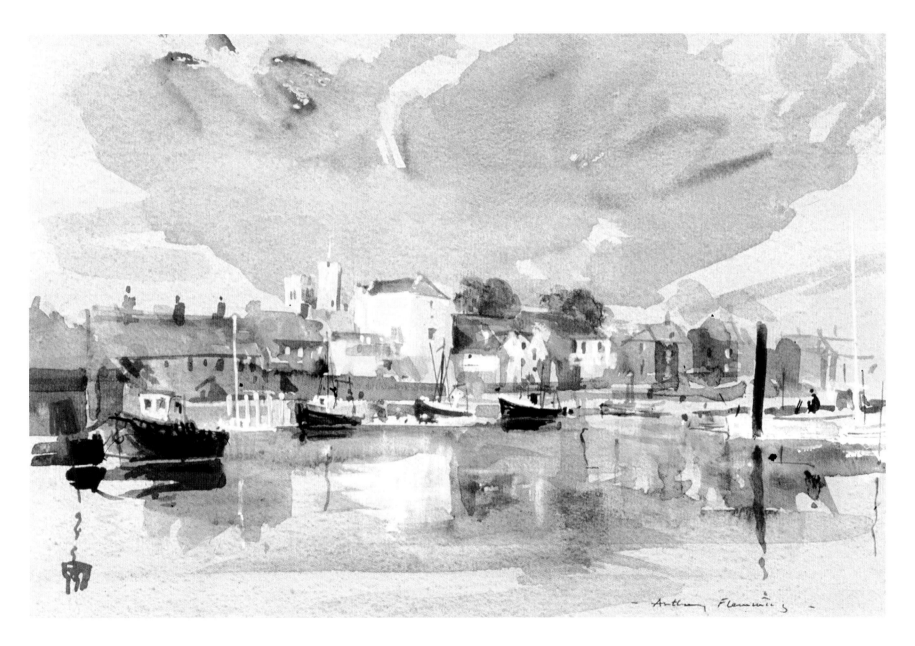

The Quiet Harbour, Queenborough. *Watercolour. 8 × 10 in. / 20 × 25 cm.*

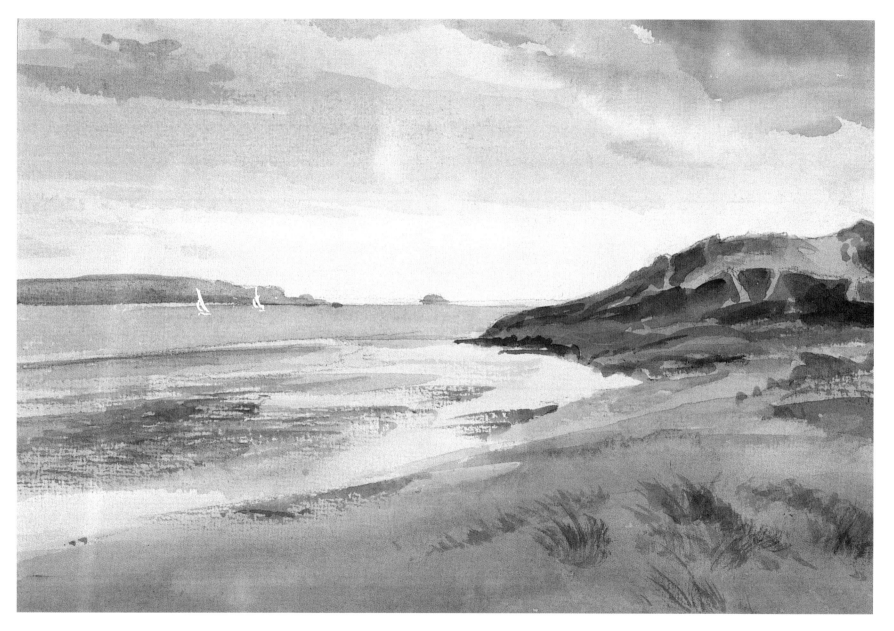

Estuary, St Valery sur Somme. *Watercolour. 8 × 10 in./20 × 25 cm.*

2. PAINTING AND SKETCHING ON THE SPOT

Which will it be, a painting or a sketch? There are many outside influences that will decide this for you, such as: how much time is available; is the weather set fair for the foreseeable future; can you find a secure spot to settle; and, above all, what equipment do you have with you? Given that all of the above are in your favour a picture may be, indeed should be, attempted.

With a stormy sky approaching, granny wanting her tea, or the skipper wishing to set sail, a sketch will be more appropriate. Above all, do something; don't miss an opportunity.

The choice of equipment is discussed more fully in a later chapter, but the overriding objective should be to have gathered together everything you will need, and to keep it close at hand. Preferably,

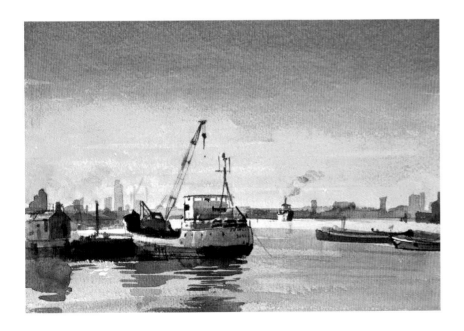

Painting: The Thames at Bugsby's Reach.
Watercolour. 6 × 9 in. / 15 × 23 cm.

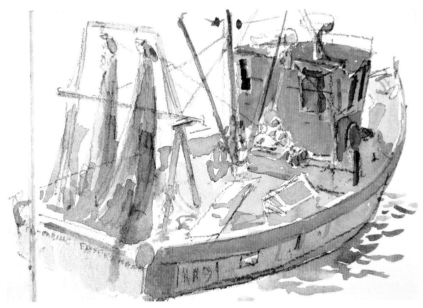

Sketch: Fishing Boat, Faversham.

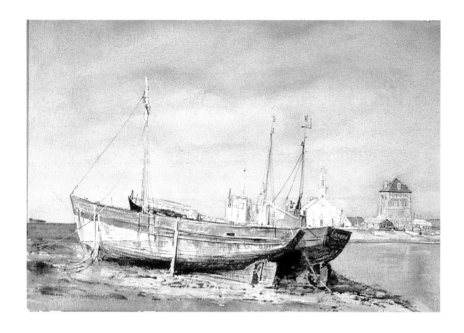

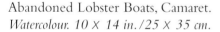

Abandoned Lobster Boats, Camaret.
Watercolour. 10 X 14 in./25 X 35 cm.

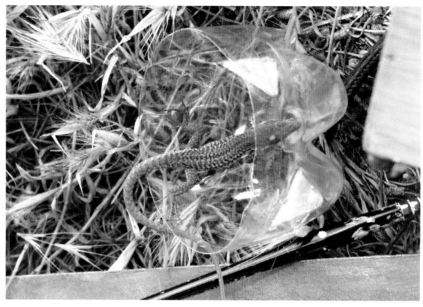

Gecko in my painting water – a welcome distraction.

your whole equipment should be light enough to carry in a bag or rucksack. The more experienced you become, the less cumbersome this load will be.

Assuming you have your perfect view in front of you, and the perfect spot to attempt your painting, there will still be further distractions.

People and animals seem to be drawn to a painter like iron filings to a magnet. Children will appear from nowhere and crowd round you, chattering and obscuring the view. They will ask questions of you, such as 'What are you painting?' or 'Are you an artist?' One of these small people, having looked over my painting for a while, sniffed and said, 'If I had done that I would give up.'

Cows are particularly curious creatures and seem to think paintings are there for licking. On one occasion a swan devoured a whole tube of red paint from my bag: if you happen to see a pink swan at Henley, you will know how it became that way. One day, whilst I was painting on a dry hillside in Italy, geckos appeared from nowhere to drink from my painting-water container.

Disasters apart, it is so often the case that the act of painting will so absorb you that you will find that several hours have passed and a picture has emerged. This picture, good, bad or indifferent, will have given immense satisfaction. Whatever the results, I commend the endeavour to all.

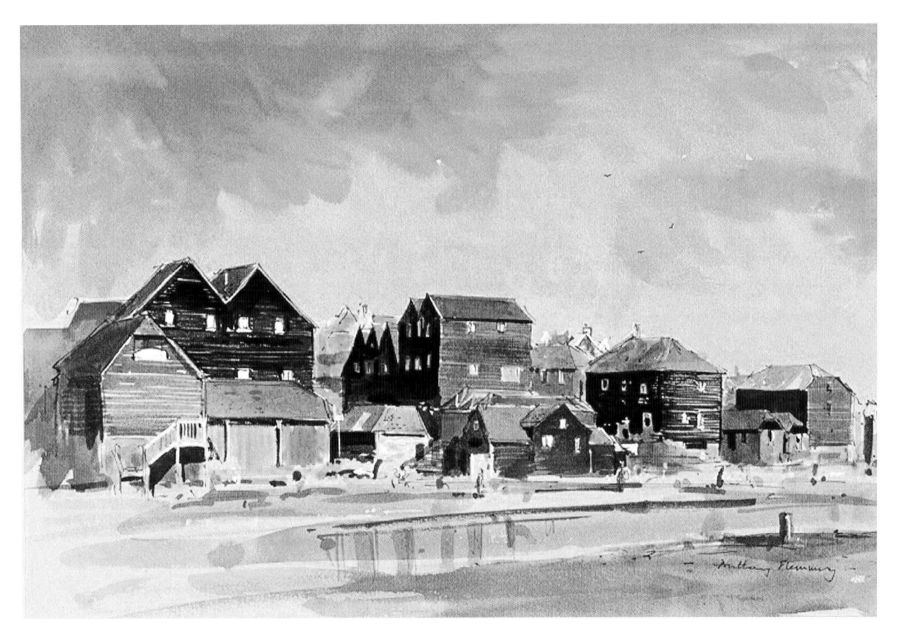

Harbour Buildings, Rye, Sussex. *Watercolour. 9 × 13 in./23 × 33 cm.*

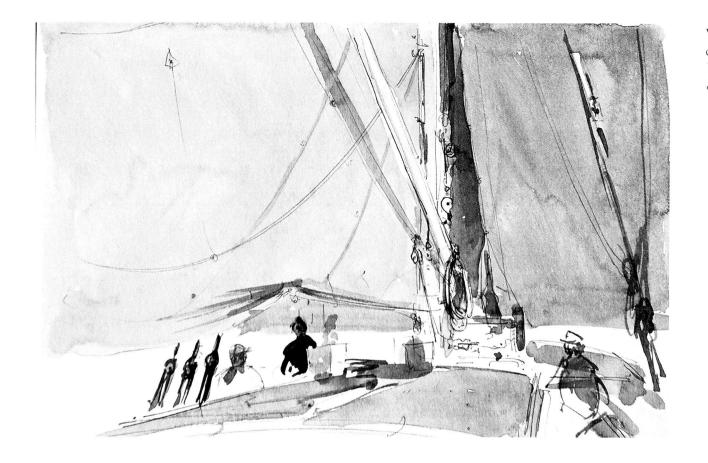

View on the deck of 'Gladys',
during a Thames Barge Match.
Watercolour.
8 X 10 in./20 X 25 cm.

Painting afloat

If you are a sailor or crew member, you are fortunate to have scenes presented to you that are unavailable to our landlocked cousins. But painting aboard a small boat on the move is almost impossible. These are the times for a small sketchbook and pencil sketches. At anchor, though, with a meal being prepared in the galley below, the opportunity often presents itself for a more ambitious sketch. A gratifying side effect of starting to make a painting at such times is that one is excused those tedious chores, such as scrubbing the decks or licking the bilge. But beware of dropping any paint on the master's pristine teak deck!

Painting aboard a larger vessel, such as a Thames barge, a tug or a coaster, is quite a lot easier.

I have made numerous sketches and paintings aboard such craft. Subjects range from views on deck, other craft or merely a sky. Usually these fall into the category of quick sketches, but occasionally the view along the deck will remain unchanged long enough for a more finished work.

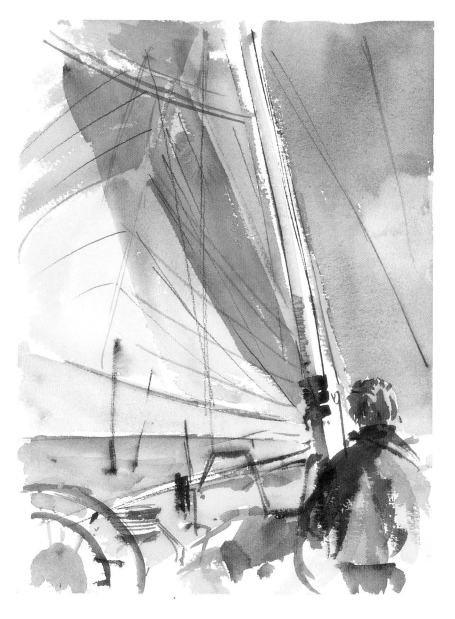

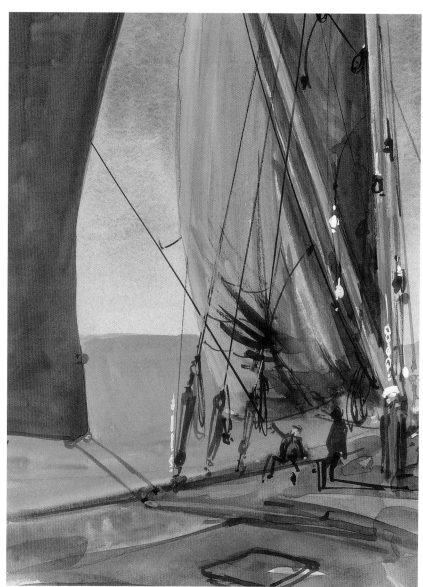

Reduced Sail. Aboard 'Crusader' Making Passage.
Watercolour. 11 × 8 in. / 28 × 20 cm.

Another view on the deck of 'Gladys'.
Watercolour. 12 × 9 in. / 30 × 23 cm.

3. EQUIPMENT

I think it was Sargent who said, when asked advice about painting outdoors, 'Don't use a canvas so large that you can't see round it.' Good advice. On one occasion I was attempting to paint a delightful Dutch harbour using a full imperial piece of paper. Not only was it a bit cumbersome on my tiny easel, but a gust of wind sent it flying into the harbour. Some amused Dutch fishermen rescued it with a large, sharp boathook! In this case the immersion improved the painting, but it still bears the mark made by that boathook.

Dennis hard at work. *Pencil. 6 × 8 in. / 15 × 20 cm.*

For painting outdoors the major considerations with regard to equipment must be to do with weight and bulk. For watercolours you will need: easel, drawing board, palette, paints, brushes, water and a chair or stool. (This last item can be excluded if you are prepared to stand and work.)

Easel
The important thing about an easel for watercolour is that it should be adjustable for tilt. To lay a wash requires a gentle slope. Too steep and the colour will cascade into your lap.

There are numerous easels on the market, ranging from wood through to aluminium. Wood is probably the most sturdy, but also probably the heaviest. Steel tube comes next in weight, followed by the lightest aluminium. One colleague with whom I have painted has the lightest set-up I have come across. He uses a very light aluminium camera tripod with a clever adaptor to take his board. His way of preventing such a lightweight kit being blown away is to suspend his bag below the tripod. In this are his water bottle, sandwiches, sketchbook and spare paper.

Drawing board
A standard drawing board is fine, but quarter-inch plywood is lighter and less bulky. When painting outdoors I suggest half imperial is the largest practical size (57 x 39.5 cm/22½ x 15½ in.), with quarter imperial being a more convenient size to carry.

Sydney concentrating on his work. *Oil sketch. 12 × 8 in./30 × 20 cm.*

Paper

Paper, like the selection of colours, is a matter of personal preference. In general, though, good-quality acid-free cotton-rag paper should be chosen. The weight of paper also makes a difference. These days paper is usually measured in grams per square meter (gsm): 180gsm, the lightest, will tend to cockle if it is not stretched; 300gsm is far less likely to cockle and can be held to the board with clips or masking tape; 600gsm, being the heaviest, is almost impervious to cockling. (The old imperial weights are: 90 lb, 140 lb and 300 lb respectively.)

Watercolour paper also comes in convenient books or blocks. The blocks are gummed together along their edges. This goes a long way to avoiding the dreaded cockle, but the paint should be allowed to dry thoroughly before the top sheet is lifted.

Paints

Watercolours come in two forms, namely pans and tubes. Each has its advantages and disadvantages. Pans are usually secured in a folding paintbox with built-in palette. The advantage of this system is that the colours are always available and in the same order. Being in the same order may seem a strange reason to highlight as an advantage. But I would liken it to a musician preferring the keys on a piano to stay where he expects them to be. In my case the selection of colours appears almost uniformly dark, so a known order is helpful.

The main advantage of tubes is that they are usually moist and more easily mixed. A disadvantage is that, if they dry in the tube, they are difficult to get at. The earth colours are the ones most prone to this drying in the tube.

In either case the selection of colours is one of personal choice. I recall that on one occasion, whilst on a painting trip in Belgium, I had my painting equipment stolen. Fortunately, a colleague was

Paul painting in the Italian sun. *Pencil. 5 × 7 in. / 13 × 18 cm.*

painting in oils, so I was able to borrow his watercolours. I had great difficulty with these, as his selection of colours was so different from mine. None of my favourite colours were there!

As a matter of interest, on the page opposite is the full range of colours I keep in the small paintbox that accompanies my sketch-book wherever I go.

No greens? Well, in fact, a variety of greens are available from various combinations of colours on top of the opposite page.

The titanium white is included for when I use tinted paper, either for adding the white itself or for producing a pale-blue sky or a lighter version of the browns, yellows or reds.

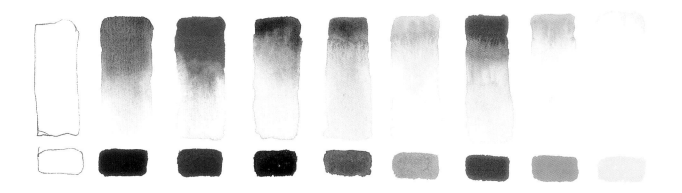

From left to right:
Titanium White
Lamp Black
Ultramarine Blue
Van Dyke Brown
Burnt Sienna
Yellow Ochre
Cadmium Red
Cadmium Yellow
Cadmium Lemon

Mixed greens, made using only the yellows plus black.

The above palette is a limited range of colours for use outdoors. Painting in the studio, on the other hand, places no restriction on the range of colours. Weight and bulk are not a consideration here. A fuller range, with more blues, browns, reds, oranges and, if you must, greens, can be used.

Brushes

For watercolour there is no doubt in my mind that sable brushes are the best, though they are also the most expensive. A well-made sable will hold more pigment, come to a finer point and work for longer. I have several sables that I purchased as a student that are still in regular use some forty years on! Take care of each one by washing it with clean water and setting to a point.

4. THE SKETCHBOOK

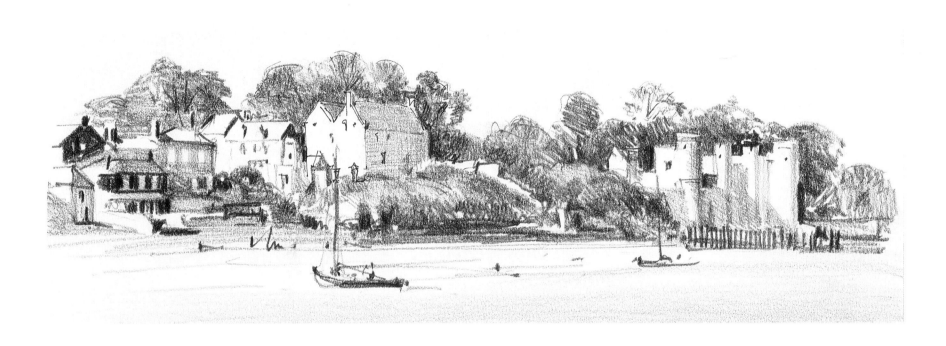

Above: From the moorings, waiting for the tide.
Pencil. 4 X 10 in./10 X 25 cm.

The sketchbook is one thing you should never be without. A small book and a pencil that will fit a pocket or a handbag is the bare minimum for any aspiring artist. Here you can capture that fleeting moment, the person opposite or the shape of a cloud. Each line you make, however tentative, will recall the moment to you. Each line you make will improve your skill. Forget the camera, but never forget your sketchbook. It is here that glimpses of the world will be recorded for you. There is no need to show or exhibit these pages. Like a diary to a writer, they are mainly for personal consumption.

Even in the field, when you are fully equipped to paint your masterpiece, the sketchbook can be used to make notes of details, work out the composition or just test a colour. So many of the sketches I have made whilst waiting for a wash to dry or a cloud to pass have inspired me to create another painting in the studio. Figures in particular can be captured and used later to enliven a painting with human interest.

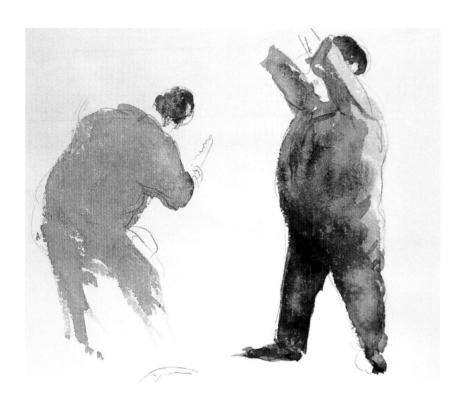

Cheerful craftsman working on boat, Syros, Greece. Pencil, pen and wash.

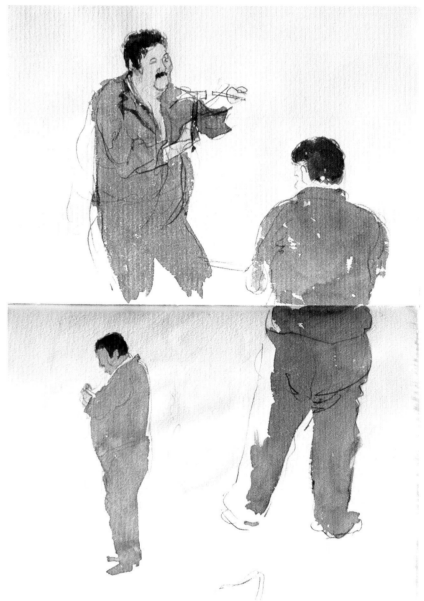

The sketchbook is the place to attempt to get the subtle shape of a ship or dinghy before putting it into your 'real' painting. This will make you bolder with the lines or brushstrokes in your finished work.

Colour in a sketchbook is fine, but consider restricting its use. A line drawing with a single colour wash will indicate the overall pattern of shadows. Sketch just the two colours of those adjacent boats. There is no need to put in the sea or sky. If you need the sea and sky, make a separate sketch of these. Later, in the studio, great fun can be had assembling these fragments into a finished picture. A sky made on one occasion can be combined with a foreground from another. In making such a compilation, be aware that it is better that the shadows fall in the same direction.

 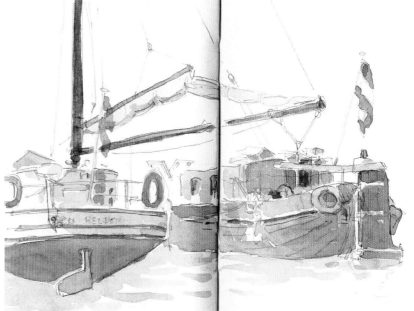

Two pages from sketchbook. *6 x 10 in./15 x 25 cm*
Above: Pencil, setting the shape.
Above right: Adding colour and pattern.

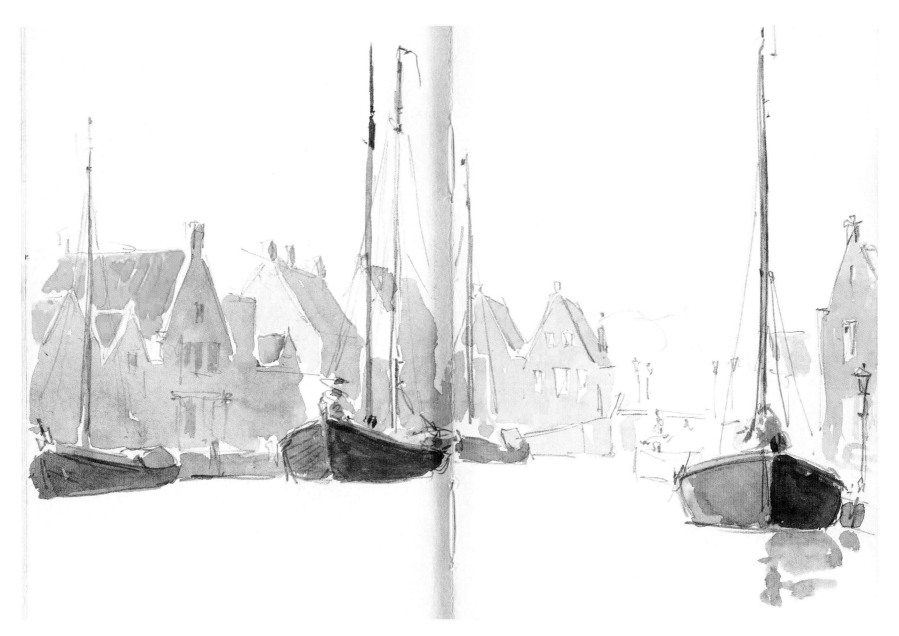

The Quiet Harbour, Monnickendam, Holland. *Pencil and wash. 6 × 10 in./15 × 25 cm*

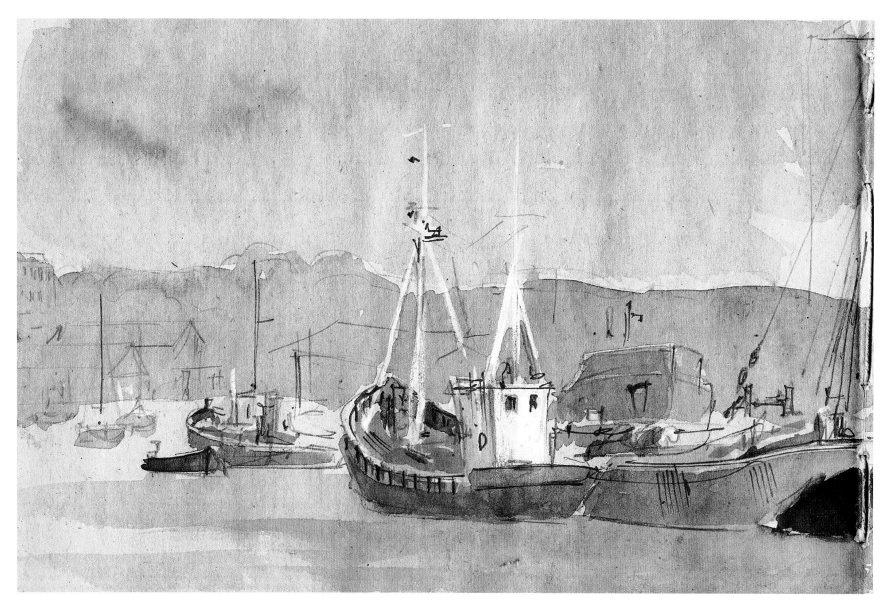

Craft on the River Medway. *Watercolour on tinted paper. 8 X 10 in./20 X 25 cm.*

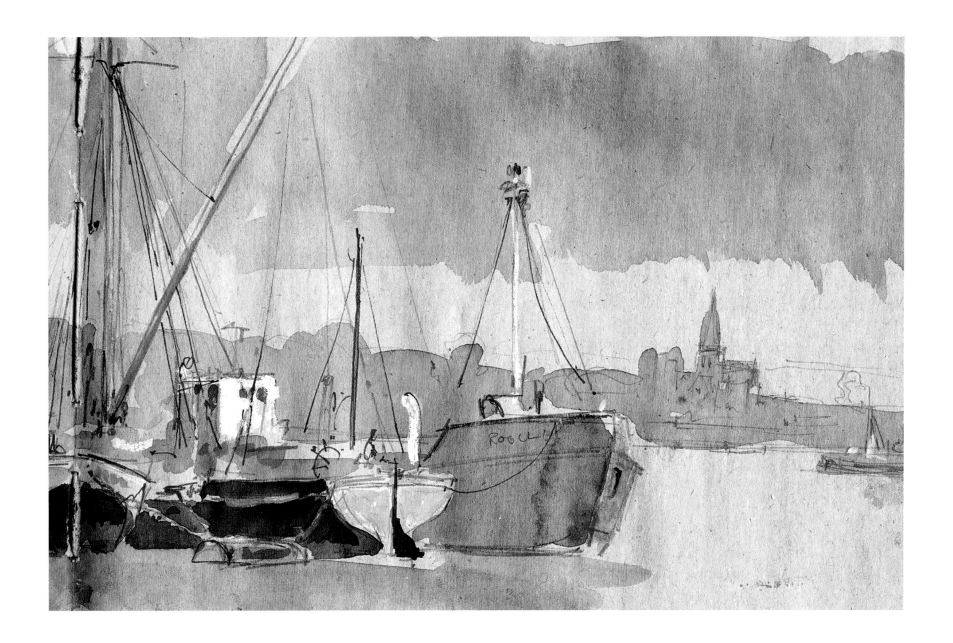

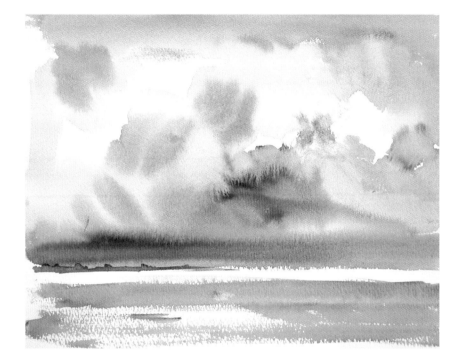

5. QUICK SKETCHES

Almost by definition the word 'sketch' implies speed of execution; something less than complete, not necessarily finished. Therefore, a quick sketch will be one where one knows at the outset that there is little time available. There are various techniques and tips that can be employed to speed things up. A pencil sketch with written colour notes is one approach.

If colour is used, attempt to keep areas of colour separate. For instance, leave a gap between the sky and the sea. Leave out local colour altogether; usually I merely indicate the light and shade with a single wash of neutral tint or sepia.

The other time for a quick sketch is whilst waiting for a wash to dry on a more finished painting, for example, an alternative group of figures, a lobster pot, or a more detailed drawing of rigging.

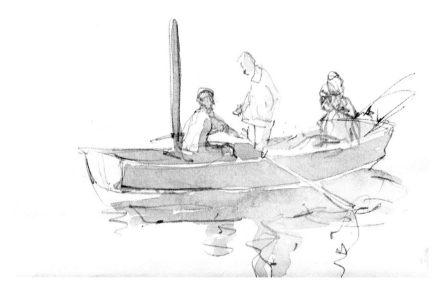

Above: A quick sky sketch. Watercolour.

Left: A passing group - a quick sketch made whilst a wash was drying. Pencil, pen and wash.

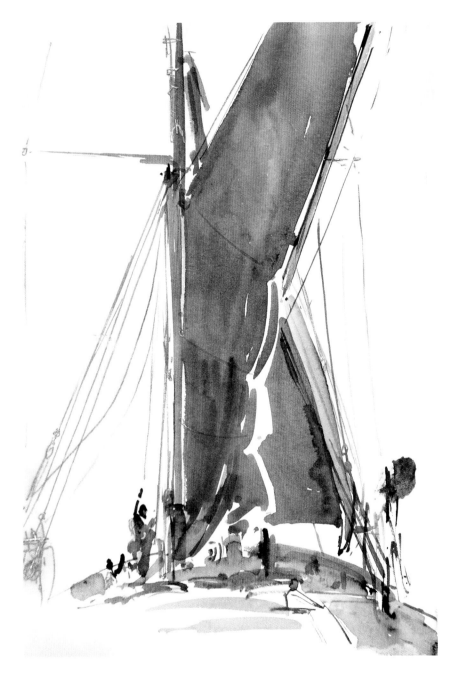

Far left: Setting sail, aboard
Thames Barge 'Hydrogen'.
Pen, pencil and wash.
10 X 7 in./25 X 18 cm.

Left: The skipper, aboard
Dutch schooner.
Pencil, pen and wash.

Below: Fishing smack with
scandalised sail.
Pen and wash.
10 X 14 in./25 X 35 cm.

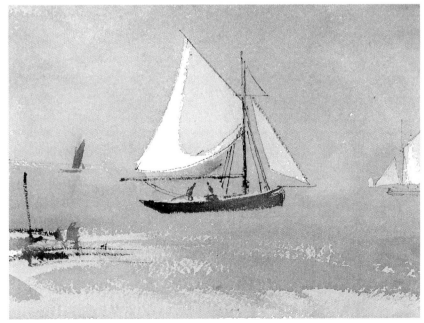

6. VERY QUICK SKETCHES

Sometimes there is so little time available that one is tempted to say it would be impossible to attempt a sketch, but with a bit of practice a few lines will be sufficient to act as a reminder. These lines might appear almost meaningless to another person, but even the slightest scribble will recall the moment sufficiently to allow further development. Consider the sketches below.

These were made passing the White Cliffs of Dover in a yacht making ten knots over the water. The following sketch was made later in the studio, using only the previous sketches and the memory they evoked.

I still intend to develop this theme further, perhaps into a larger oil painting.

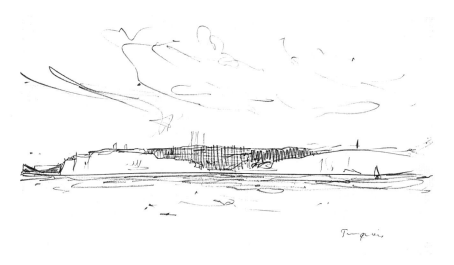

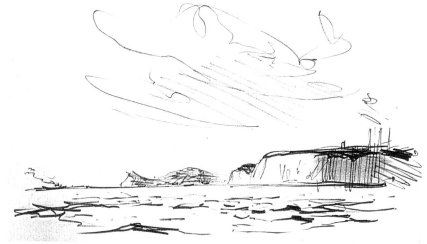

Above, and above right: The White Cliffs of Dover. *Pencil sketches, made in the log book. 4 × 7 in. / 10 × 18 cm.*

Opposite: Colour sketch, made from memory and the sketches above.

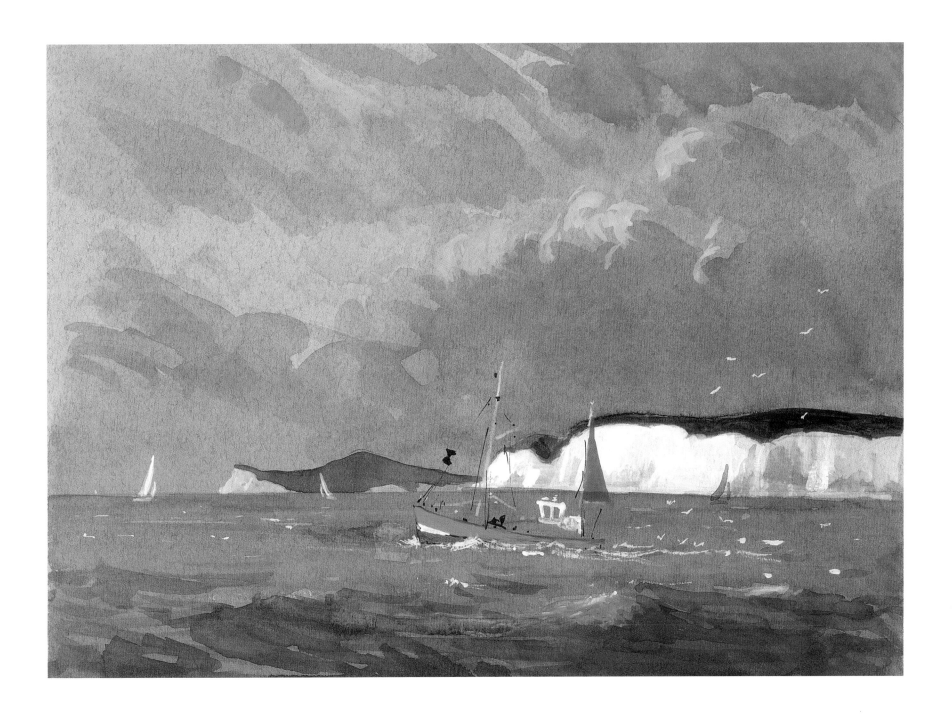

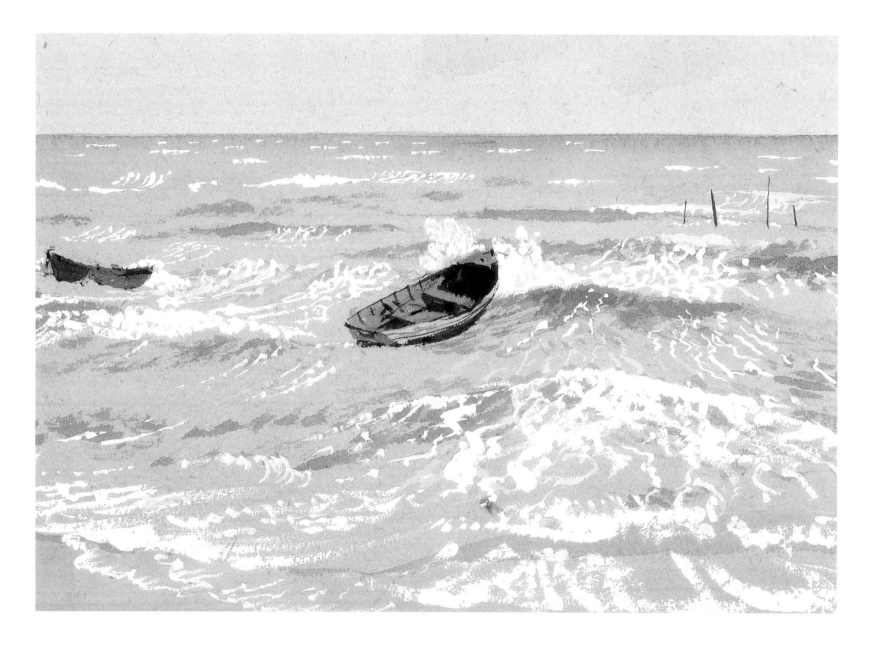

Breaking Waves. *Watercolour and bodycolour. 10 × 14 in. / 25 × 35 cm.*

7. TINTED PAPER

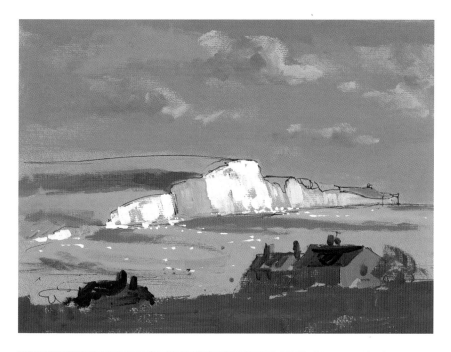

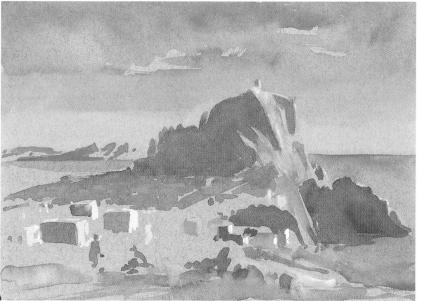

There is one great advantage in using tinted paper, namely that the tone is immediately taken away from a glaring white. If whites are required they can be added with body colour, either poster colour or a waterproof white such as Plaka. The advantage of a waterproof white is that it can be tinted at a later stage without lifting or bleeding.

In the sketch on the opposite page, it can clearly be seen that the starting colour is a buff-tinted paper. A wash of neutral tint and ultramarine blue indicates the area of water. When this wash was dry, more of the same mix was added to indicate the waves. Next the boats were added using Indian ink. Then the surf was picked out with poster white. Finally, the boats were tinted with sepia and blue. Imagine the difficulty of attempting to lay a wash while at the same time leaving the white paper exposed in all the right places to indicate the surf.

The sketch *The White Cliffs* was made on grey-tinted paper. Note here that the clouds were deliberately muted so as not to appear too bright, thus emphasising the gleaming white cliffs.

The *Acropolis at Lidos* is also on tinted paper, with the buildings picked out with poster white. This picture also shows the technique of drawing with a brush; there are no pencil lines. I do notice, however, that the horizon is on a different level either side of the headland, so perhaps a pencil line would have helped here.

Left, above: The White Cliffs. *Watercolour and bodycolour.*
8 × 10 in./20 × 25 cm.

Left, below: Acropolis at Lidos. *Watercolour and bodycolour.*
8 × 10 in./20 × 25 cm.

8. PAINTING IN THE STUDIO

Painting in the studio is a far cry from painting on the spot. There is no restriction on the size of paper or canvas that can be worked on. There is also no restriction with the size of palette or the number of colours. Above all, there is no rain, wind or blistering sun.

Time is also no longer such a pressing matter. Several paintings can be in progress at once. Part-finished paintings can be placed in a frame so as to judge how they are coming along. This is a particularly good way of seeing when a picture does not need much more doing to it.

Here is the place to bring together all those sketches into a more considered composition; to reinterpret that on-the-spot painting without the disastrous colour that somehow appeared.

There are disadvantages, of course, to all this time and comfort. It is all too easy to lose the spontaneity of capturing things directly from nature. On the spot, a figure will appear to fill that empty space, or the changing light will suddenly highlight an object for you.

In the studio, it is also far too easy to rely on the photograph; simply to copy all those colours that the camera has captured in that frozen fraction of a second. If you are interpreting a sketch you have previously made on the spot, rely on the colour notes you made at the time. Only make recourse to the photograph for factual information: the run of the rigging, or the number of windows in a particular building.

The picture opposite is a painting made in the studio from the two sketches shown with it.

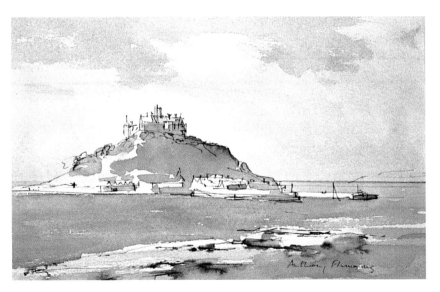

St Michael's Mount *sketches.*
4 × 8 in./10 × 20 cm and 6 × 8 in./15 × 20 cm.

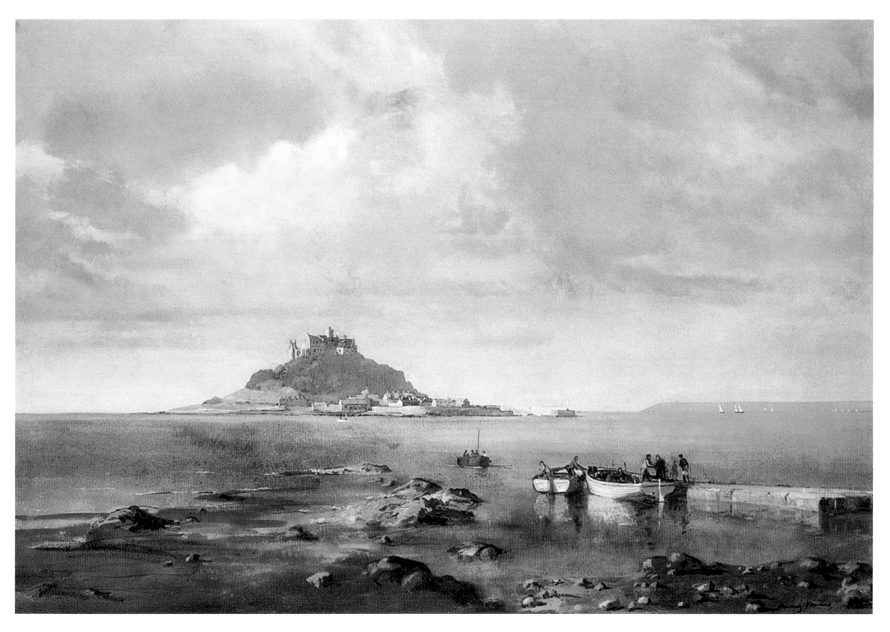

St Michael's Mount. *Oil. 24 × 36 in./61 × 91 cm.*

The Royal Yacht
Squadron, Cowes, Isle
of Wight.
*Watercolour. 14 × 18
in./35 × 45 cm.*

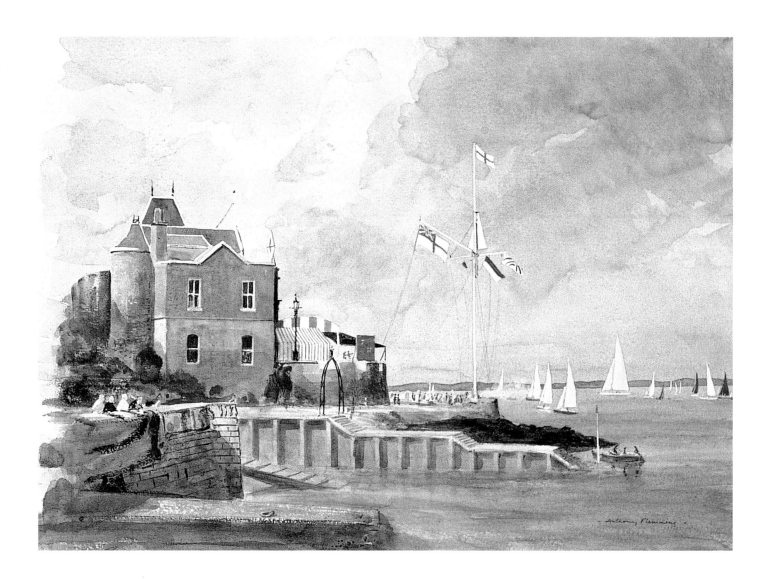

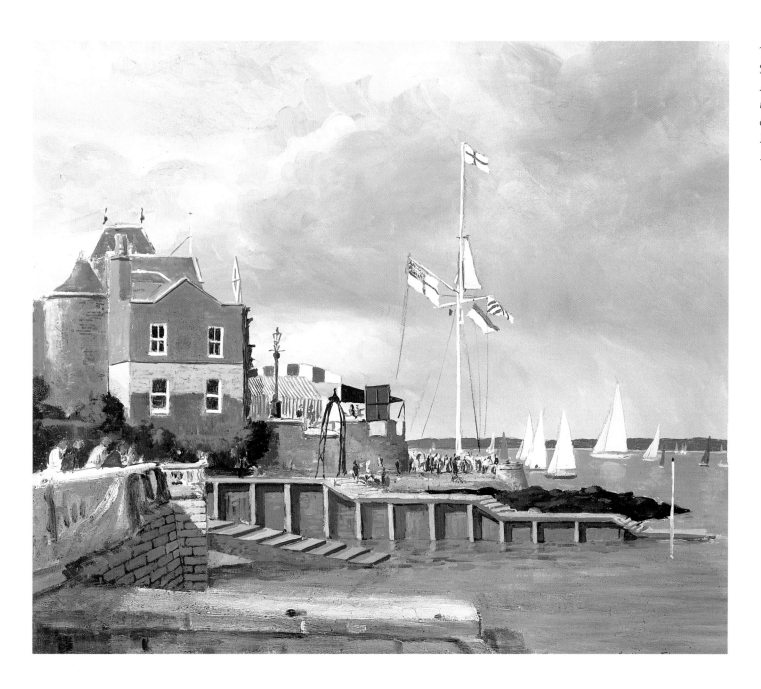

The Royal Yacht
Squadron.
*A studio painting
interpreting the study
opposite. Oil.
20 × 24 in. /
51 × 61 cm.*

9. COMPOSITION:
MANIPULATING OBJECTS TO SUIT

Even when sketching on the spot you should pay some thought to composition. Look carefully at the scene in front of you and decide which portion will make a satisfactory subject. You may find it helpful to carry a small piece of card with a square aperture cut into it. This card, when held up and peered through, serves to eliminate distractions and concentrate one's attention on a manageable portion of the scene. When you hold the card close to the eye, the scene is larger; extend the arm and the view is reduced. Usually, this 'zoomed in' view is easier to cope with. A camera with a zoom lens can serve as a scene selector in a similar way.

At this stage it will be helpful to make a thumbnail sketch. On a scrap of paper, or a page of your sketchbook, make a small pencil sketch. In this sketch, which should be no larger than a credit card, block in the chosen view. Look critically at the sketch. If the selected portion of the scene excludes an interesting object just out of view to the right, make another composition in this small size with that object moved to the left and thus into the picture. This will only take a few minutes and may well save hours of labour at a later stage.

Even in such a tiny sketch there are some principles of composition that still apply. A horizon slap-bang across the middle is seldom satisfactory. Put a mast or a spire in the centre as well, and the picture is doomed.

There are also a couple more basic tenets for you to keep in mind: avoid lines going exactly to the corner of a picture; leave out those telephone lines, parking signs or litter bins unless you deem them important to the composition.

The above assumes a situation in which you are attempting to produce a finished picture on the spot. The alternative is to zoom in further and make a series of sketches. Take just that boat, that bollard, those fishermen over there. This approach is frequently preferable, allowing you to concentrate on capturing just the curve of a dinghy or the light and shade of a group of buildings. These selective snapshots can serve to free you almost completely from thinking about composition, allowing you to concentrate on practising other skills, such as drawing and colour. These sketches and studies are never a waste of time; it is surprising how many of them become useful in the studio at a later date. Frequently, especially with boats under sail, I have arranged a bunch of these studies into a satisfying composition.

Opposite: Sketch of the Royal Naval College at Greenwich.
The static and symmetrical composition of the buildings is broken by diagonal shadows and the addition of craft in the foreground. Although this picture is referred to as a 'sketch', it in fact measures some 12 X 15 in./30.5 X 38 cm. The final picture though measures 4 X 8 ft/122 X 244 cm (see p.112) and adorns a prestigious boardroom.

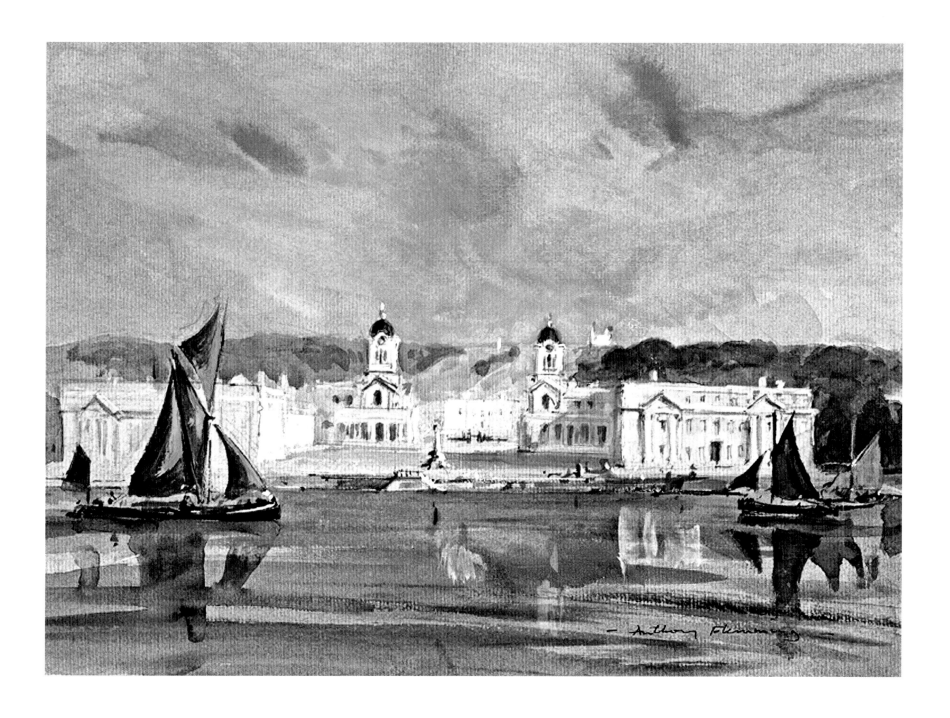

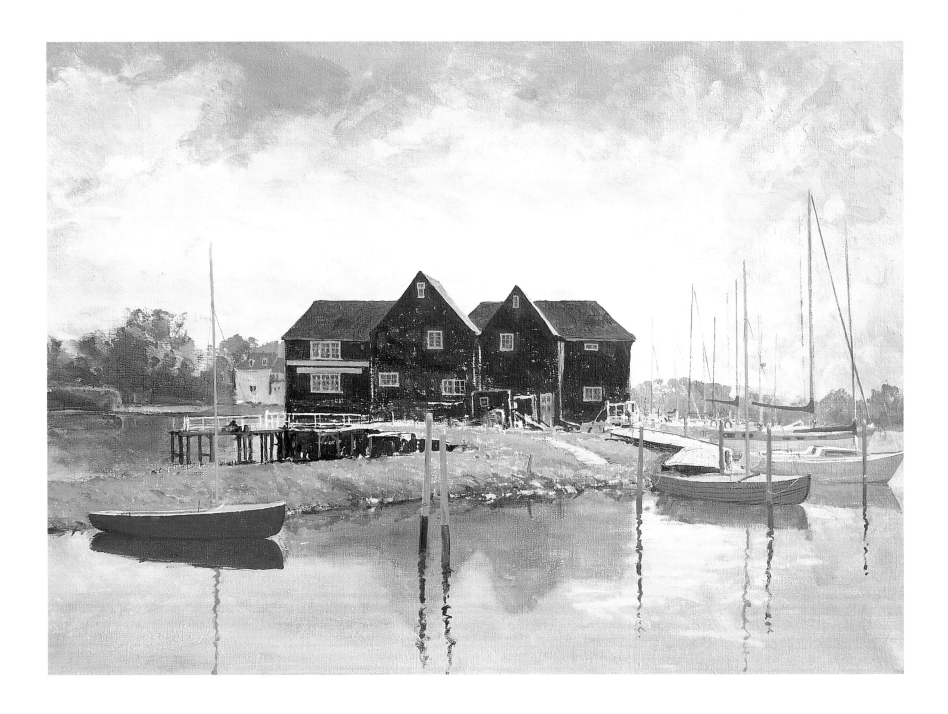

10. ARTISTIC LICENCE:
PERMISSION TO LEAVE THINGS OUT

Unlike the camera we painters can make a selection as to what we choose to include and, more importantly, what we leave out. The camera is such an undiscerning machine; it will include all those objects unnoticed by the eye, put detail where none is necessary and will even change colours. As my friend and fellow painter Tom Coates puts it succinctly, 'A camera lies!'

Compare the sketch you made on the spot with the photograph you took at the time. You should be able to see that, however diligent you were with your sketch, you will already have made a selection. You have probably simplified those trees into their overall shape; to draw in every branch and leaf would have taken too long. I trust too that you failed to include those signs directing you to the toilets, or the one forbidding parking.

The most frequent things that the beginner will leave in are telegraph poles and their wires. Next time, unless you consciously decide they are important for the composition, you have my permission to leave them out.

This selection and simplification is the basis of artistic style. With ships, boats and harbours, simplification will be made to rigging. Distant craft have less detail. Also, coils of rope and lobster pots can be reduced to their overall shape.

Perhaps the most important part of exercising this licence is the ability to move objects around in your picture, once again proving the superiority of our medium over the camera. This ability to manipulate objects is discussed more fully in the chapter on composition.

On one occasion I recall painting a street scene. The problem, as I saw it, was that there were just too many buildings to left and right. Whilst sketching the subject, I consciously left out nearly every other building. Later, when the picture was finished, it was chosen to feature in a calendar of British scenes. I was apprehensive that some irate local would pick up my deception. Far from it, the publisher received several letters from people praising my depiction of their town. In *Tide Mill at Birdham*, opposite, some dozen moored craft in the foreground were simply left out; they obscured the view and confused the composition.

Opposite: Tide Mill at Birdham. *Watercolour. 20 × 24 in./51 × 61 cm.*

11. AERIAL PERSPECTIVE: IMPRESSIONS OF DISTANCE

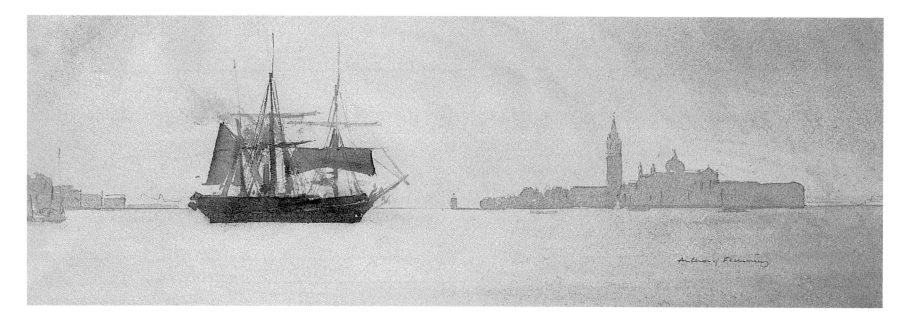

Objects in nature tend to become fainter and less distinct the further away they are from the observer. The other tendency is for all objects to take on a bluish tinge as they recede. Darks, in particular, tend to fade towards blue. (The exception is white, which will still invariably seem brilliant.)

This natural phenomenon is a useful one to capture when painting. It has the advantage of simplifying our task. Distant hills can be painted in with broad flat washes. As a general rule it is advisable to lay down these more distant objects early on in the painting, leaving spaces where lighter objects will occur.

In the picture opposite, depicting an English fishing smack passing the narrows off Reculver Abbey, the boat is treated in a stronger manner than the distant shore. Lay a small dark piece of paper over the abbey and see how this destroys the effect of recession.

This effect of recession can be captured even in a simple line drawing by using a faint delicate line for the distance and an increasingly firm and darker line for the foreground.

Above: The Lagoon, Venice. *Watercolour. 5 × 15 in./13 × 38 cm*

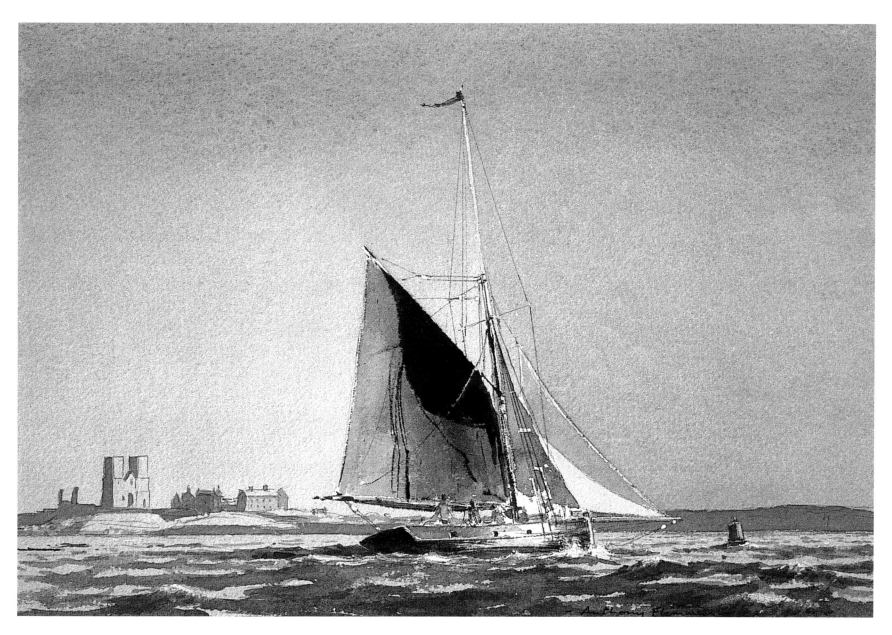

Choppy Water. *Watercolour. 9 × 12 in./23 × 30 cm*

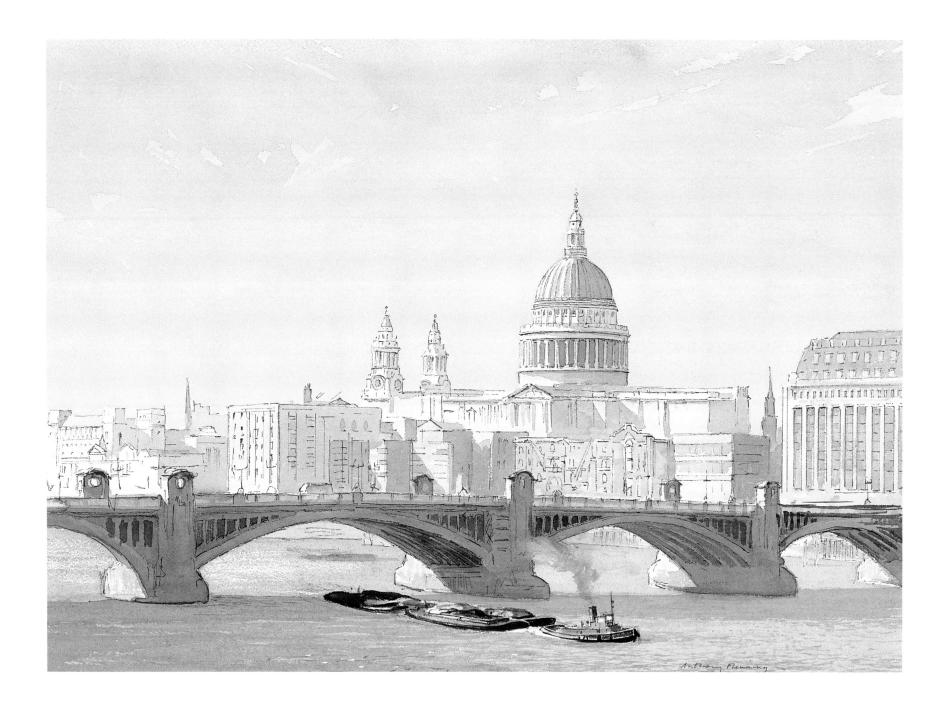

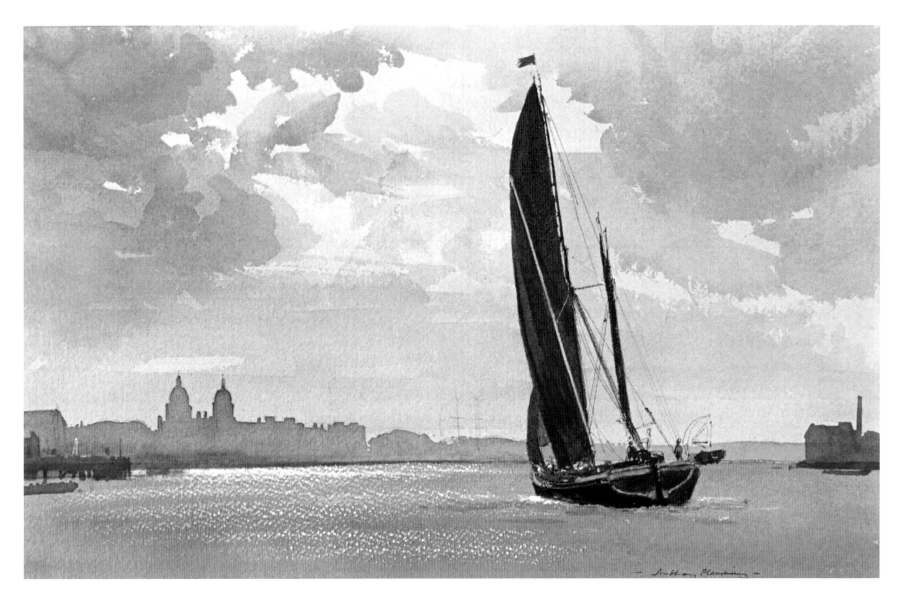

Above: Thames Barge Approaching Greenwich. *Watercolour. 10 × 15 in./23 × 38 cm*

Opposite: St Pauls Across the River. *Watercolour. 15 × 20 in./38 × 51 cm*

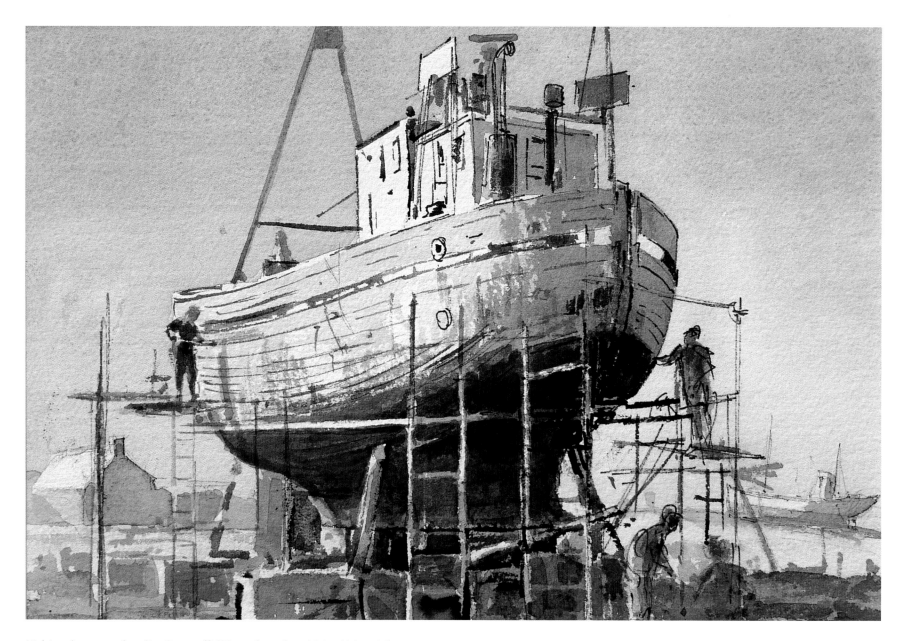

Fishing boat on the slip, Roscoff. *Watercolour. 8 × 10 in./20 × 25 cm.*

12. THE STRUCTURE OF CRAFT

Wooden boats are constructed in a very organic manner. This is most easily seen in a wooden dinghy (or tender). Starting with the backbone (the keelson), the skeleton is further made up of ribs (ribs and stringers), to which are added the skinning (planking). The final form is reinforced with the addition of seats (thwarts), bulkheads and a shaped rear end (the transom).

The skin in the illustration is made of overlapping planks (clinker) riveted together and to the frames with copper nails. The alternative, and more expensive, smooth hull is called 'carvel'.

These small craft are well worth drawing. They are fiendishly difficult to capture. There is seldom a straight line anywhere. (For a trick that may well help, see Chapter 23, 'Cheating', p.106.)

A side view of such a dinghy will show a distinct upsweep towards the bow.

Regrettably, these traditionally-built craft are all too rapidly being replaced by alternatives made of glass fibre. Glass-fibre boats are constructed using a mould. Layers of glass fibre and catalysed resin are built up in this mould, creating the hull, as it were, 'outside in'.

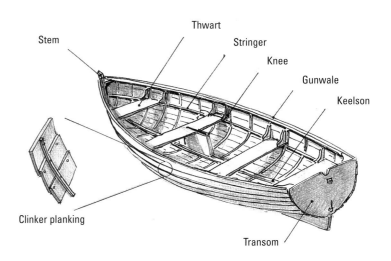

Stem · Thwart · Stringer · Knee · Gunwale · Keelson · Clinker planking · Transom

Left: Abandoned fishing boat. *Pencil. 10 × 12 in./25 × 30 cm*

Above: A clinker dinghy. *Pen.*

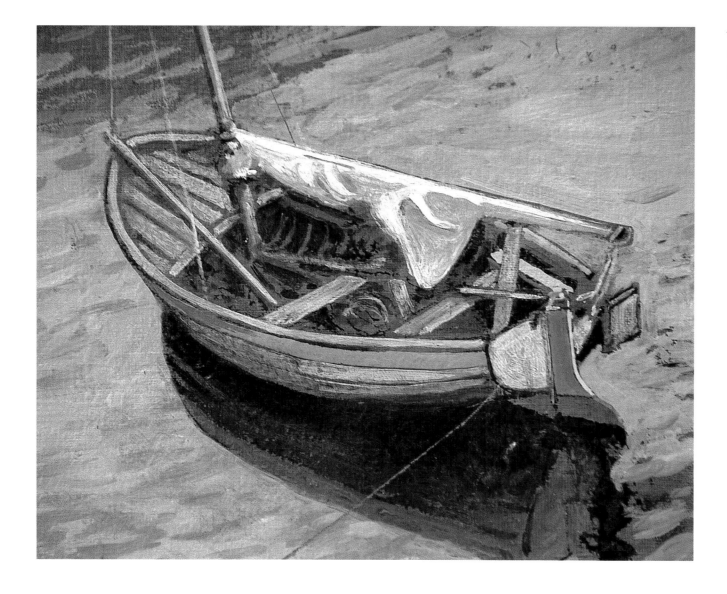

Wooden sailing dinghy.
Oil sketch.
8 X 10 in./20 X 25 cm.

In the case of small dinghies, the seats and stringers are added whilst still in the mould. With larger craft, it is bulkheads that are inserted at this stage. After a period of curing, when the resin sets hard, the boat is removed from the mould, revealing its finished shiny skin.

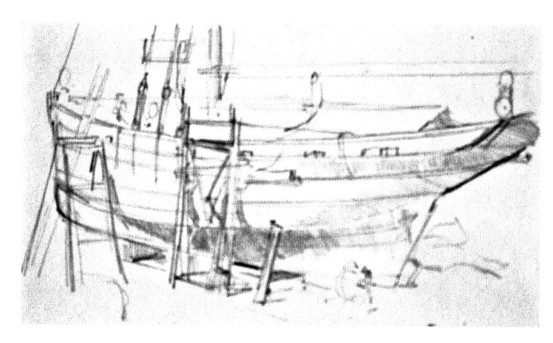

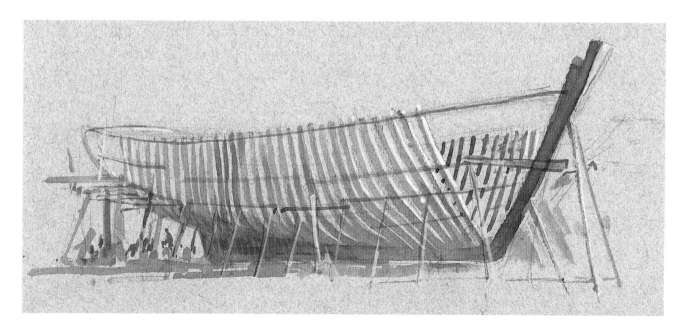

Above, left: Dutch rudders.

Above, right: Oyster smack on the slip. *Pencil.*

Right: The bones of a new fishing boat, Essouria. *Brush and body colour.*
5 × 7 in./13 × 18 cm.

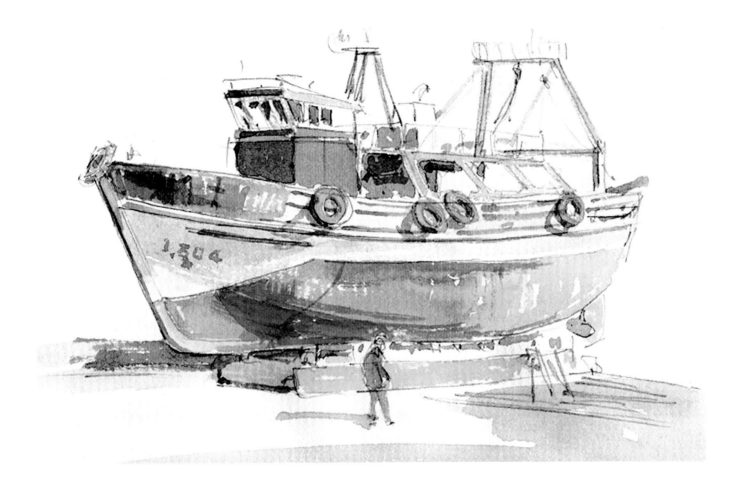

Fishing boat at Essouria.
Watercolour.
5 × 7 in. / 13 × 18 cm.

Wooden craft require far more maintenance than their modern equivalents. Wood rots, and planks need to be replaced, caulked and painted. These routine tasks also offer a great artistic opportunity. Figures hammering, sawing and generally maintaining make great subject matter, whilst all that the owners of the modern 'Tupperware' ever seem to do is occasionally apply some polish.

In so many locations boat maintenance, and even construction, is often carried out in the open air. I have been fortunate enough to paint craft in such varied locations as Turkey, Greece, Morocco, Egypt, on various islands in the Caribbean, and in the USA, as well as closer to home in the UK, Scotland, the Netherlands and France. On all these occasions I was made welcome, and I was frequently offered refreshments that varied from hot sweet tea to vodka or ouzo! There would seem to be a kindred spirit between these craftsmen and the humble painter wishing to capture their art.

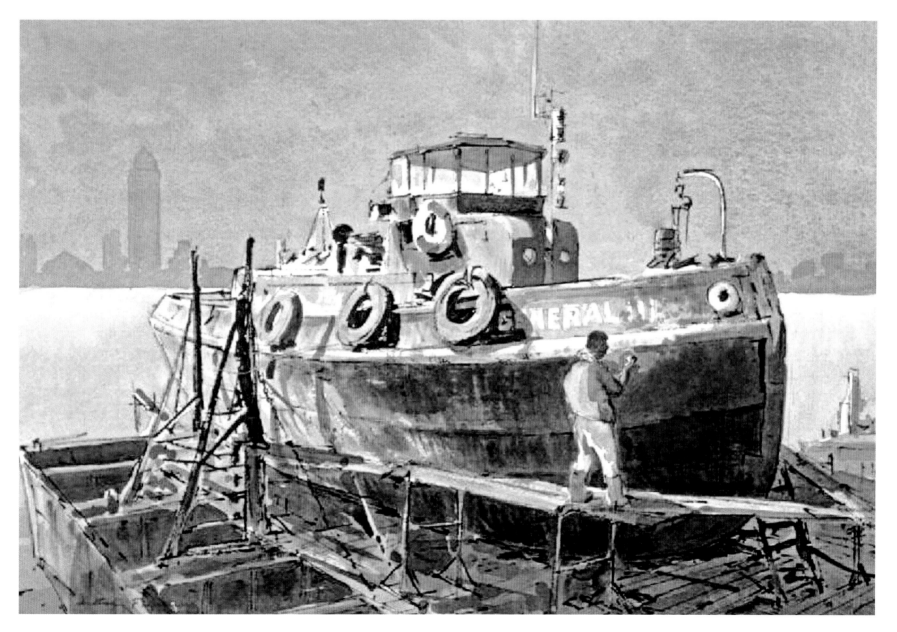

The General. *A steam tug undergoing restoration.*

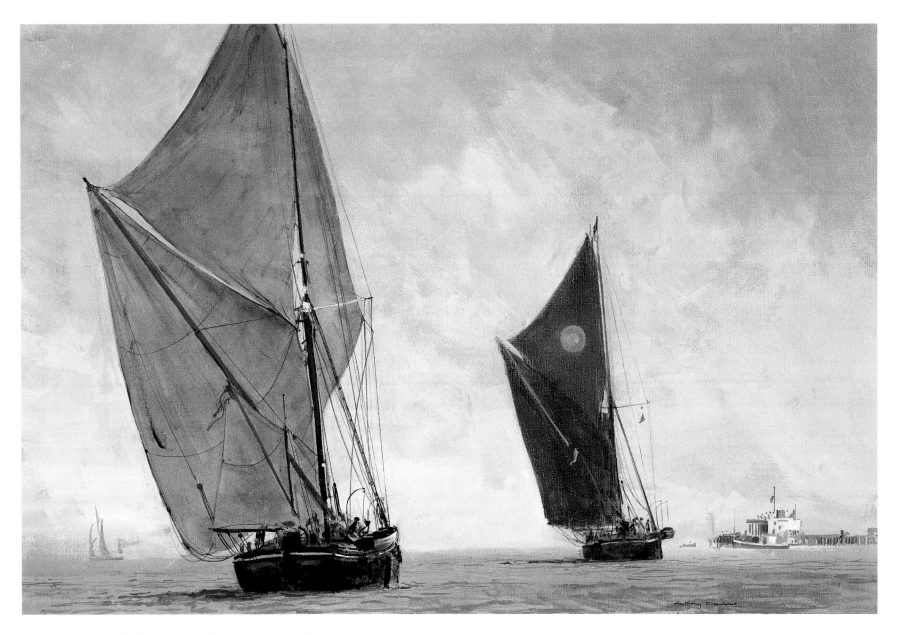

Approaching the Finishing Line, Southend Pier. *Oil. 24 × 36 in./61 × 91 cm.*

13. SAILS AND RIG

TRADITIONAL

There is a distinct divide between traditional and modern rig. The owners of traditional craft seek to maintain the authentic materials and fabric. This is in contrast to the modern sailor, who seeks high-tech solutions in the pursuit of lightness, strength and speed.

The traditionalists attempt to freeze their craft in the period when they were created, preferring to use Stockholm tar and hemp instead of epoxy resin and carbon fibre; though it must be remembered that these traditional craft were often the high-tech machines of their day. From the artist's perspective, however, a craft which has been lovingly restored or preserved allows us a wonderful glimpse into the past. How different it would be if these craft, the fishing smacks and barges, had adopted aluminium spars, Kevlar sails and shiny modern winches. Of course, almost invariably, improvements have been made to these craft. Most have had an engine fitted, and the traditional cotton sails and hemp rigging have been replaced with terylene and polyester; thankfully, though, the outward appearance has usually remained unchanged.

The Thames barge was a workhorse devised and adopted for carrying cargo up and down the River Thames to London. It was flat-bottomed, which allowed it to settle on the mud bed of this tidal river. Sail-handling was made as simple as possible for the crew of two, a man and a boy. The mainsail stays permanently aloft, held in place on the diagonal spar, called a sprit. The sail is furled aloft with brail lines when not required. Release these lines and the sail is set in an instant. Originally, there was no topsail, but the building of

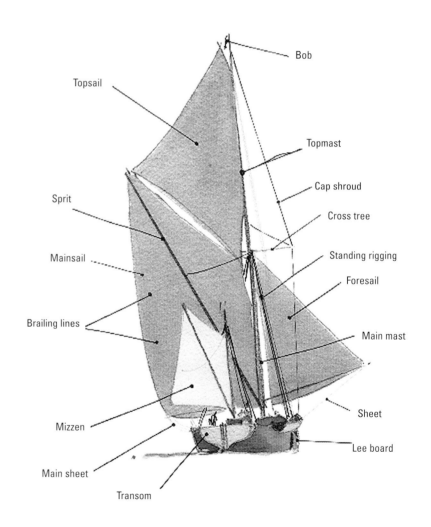

Thames Barge Rig.

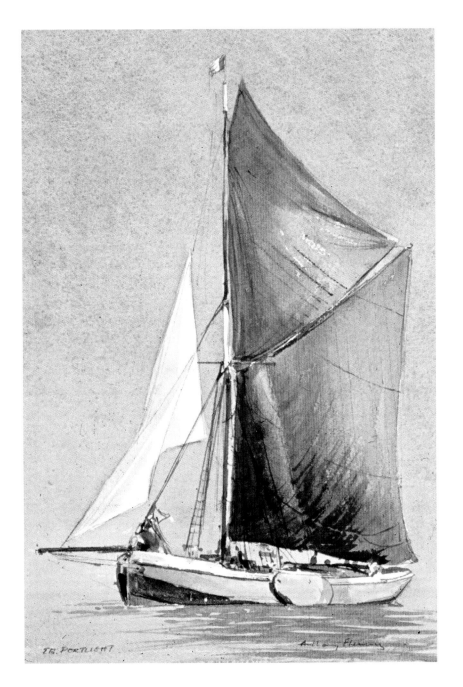

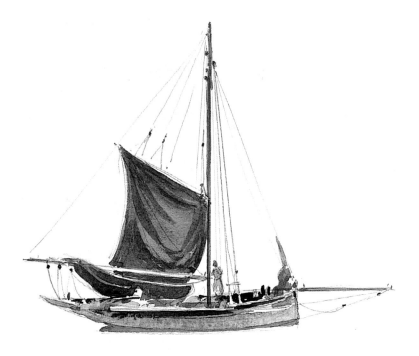

Raising sail. *Watercolour. 6 × 6 in./15 × 15 cm.*

high warehouses along the riverbank made this addition necessary to catch the wind above these buildings.

Today there are no working barges, but many are still sailing, lovingly preserved by their owners. Each year, on the east coast of England, a series of barge and smack matches is held, in which these graceful craft sail in friendly competition.

Thames Barge. *Watercolour. 9 × 11 in./23 × 28 cm.*

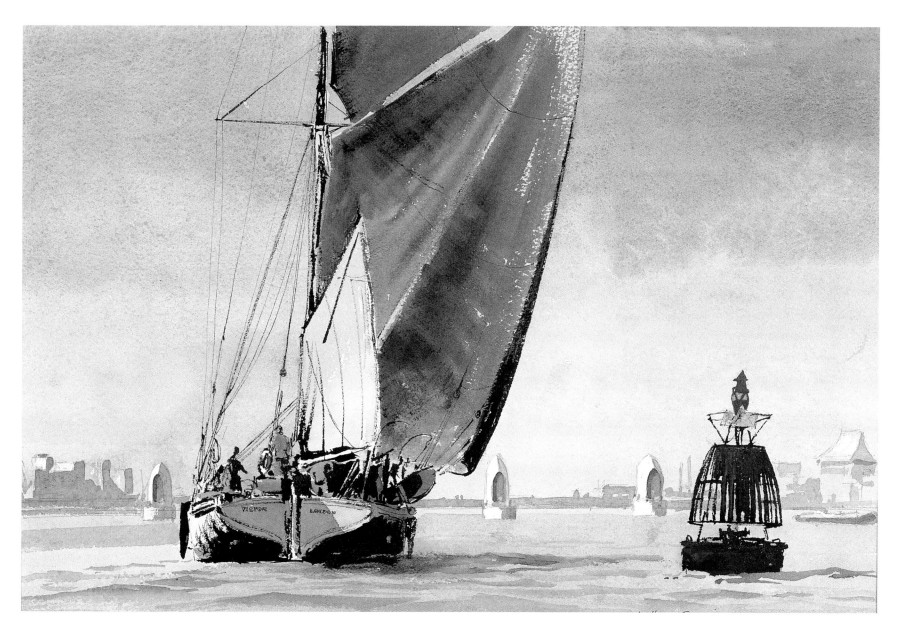

Victor, Thames Barge. *Watercolour. 7 × 12 in. / 18 × 30 cm.*

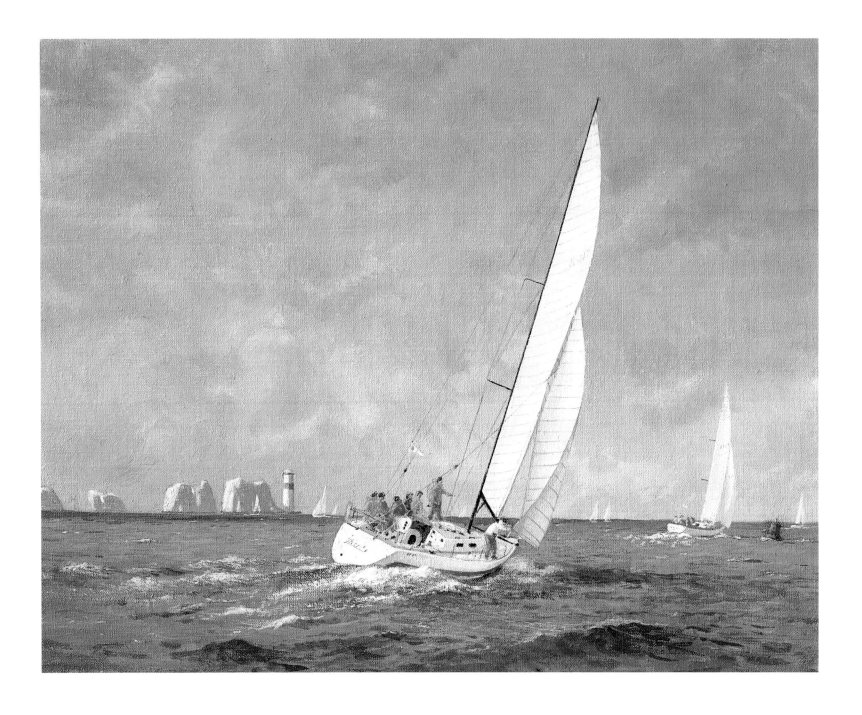

MODERN SAILS AND RIGS

Modern yachts require sails that are light, strong and hold their shape. Their spars are spindly aluminium or carbon fibre, the rigging stainless steel. The various new materials used in the production of modern sails give interesting and varied visual effects for the painter to capture.

The base of all these fabrics is a thin transparent material called Mylar. The various coloured strands are bonded in layers to this Mylar base. The straw-coloured fibres are Kevlar, the black are carbon fibre, and the white are Spectra. Each of these fibres is extremely strong in the longitudinal direction.

It can be seen clearly that in these fabrics there is distinct orientation of the fibres. The sail maker, with the help of a computer, will align these fibres with the direction of stress in a sail; hence the elaborate patterns one sees, with panels radiating from the corners of the sail. As some of these fabrics have a different colour on one side compared with the other the panels are alternated, giving a striped effect. Areas of low stress often have a lighter-weight material, and multiple layers are added at stress points. Compared with cotton and the woven fabric Dacron, these sails hold their designed shape through a wide range of wind strengths. They are impervious to dampness and rotting. On the downside, they can be astronomically expensive and, in the case of Kevlar, liable to degrade in sunlight. On smaller racing yachts the sails can be almost transparent. These sails are referred to affectionately as garbage bags.

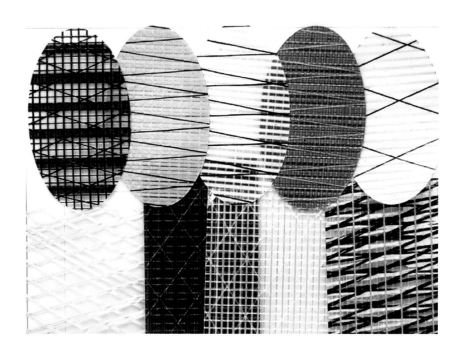

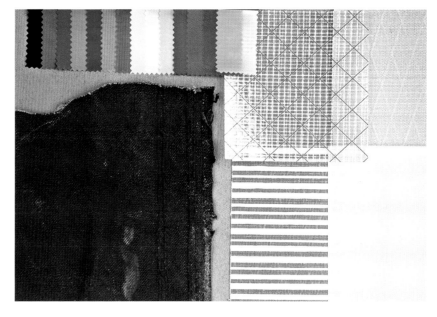

Opposite: A Fair Wind by the Needles. *Oil. 14 × 18 in./36 × 46 cm.*

Right: A selection of modern sail fabrics.
Bottom left is the cotton Thames Barge sail material.

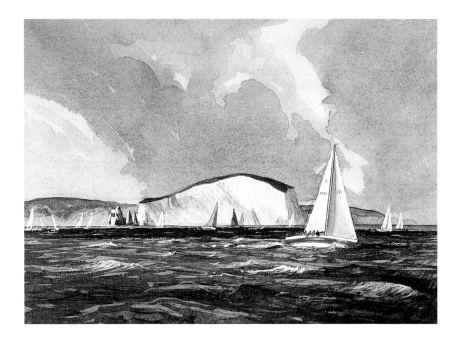

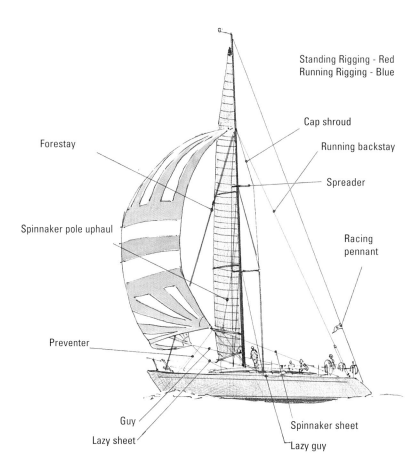

On windsurfers the sails are often pure Mylar with patches of colour, giving the effect of butterflies darting across the waves.

The rig on a modern craft can be as exotic as the sails it supports. Spindly aluminium masts supported by thin stainless-steel rigging with numerous spreaders can soar to great heights. Enormous stress is put into the backstays to tension the forestay in an effort to prevent this sagging to leeward. The spinnaker pole might be made of carbon fibre and the sheets of Kevlar or Spectra. Powerful shiny winches will assist sail handling. The grace and speed of these modern yachts is perhaps shown at its best when the spinnakers are hoisted.

Above, left: Passing the Needles.

Above: Modern Rig.

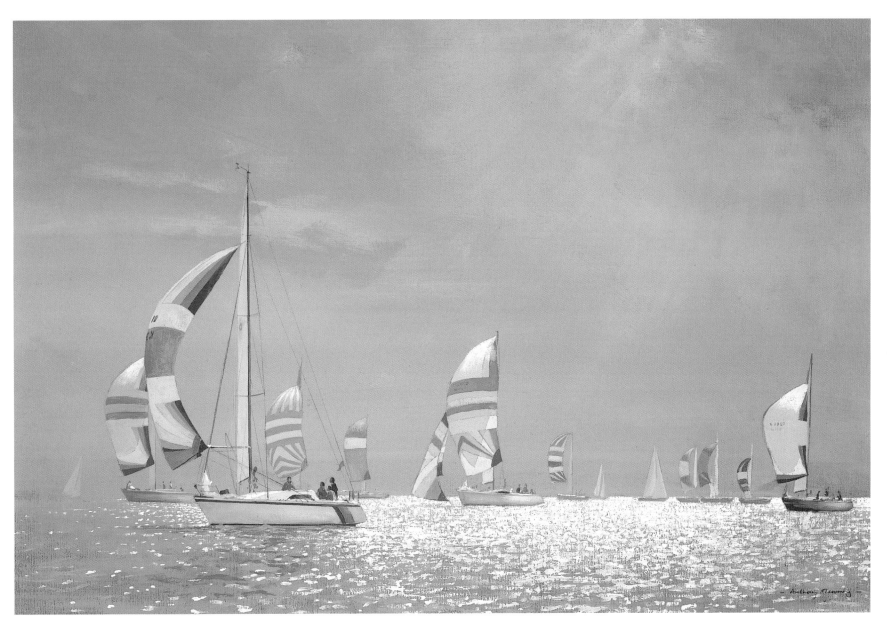

Gentle breeze and haze. Yacht race in the Solent. *Oil. 24 × 30 in./61 × 76 cm.*

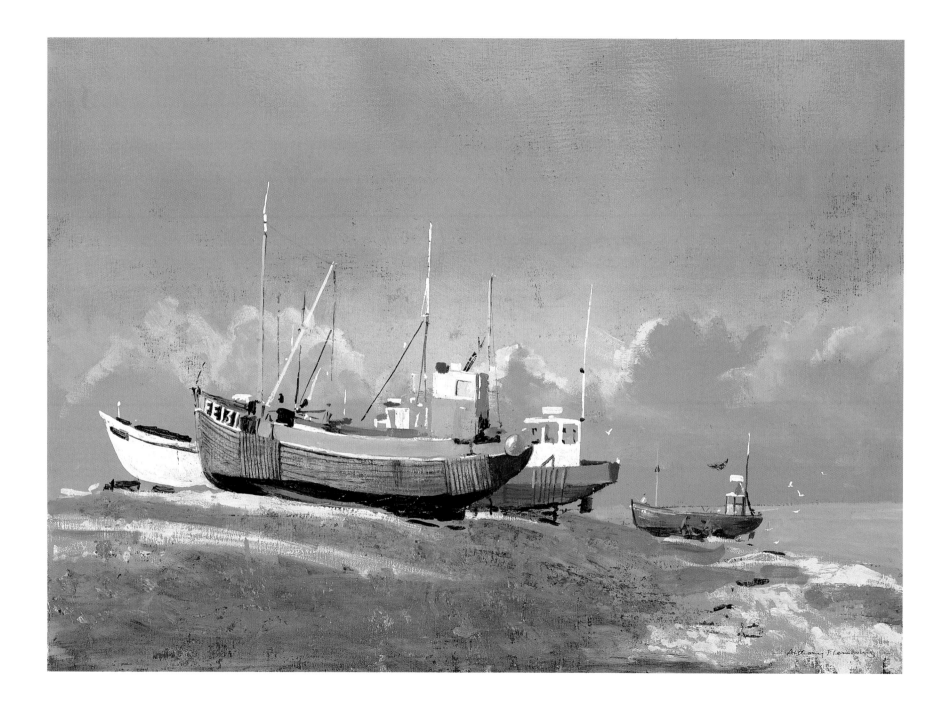

14. BOATS ASHORE

The great thing about painting boats ashore is that they tend to stay put. Although, on one occasion, during a trip to Morocco, I looked up from my painting and the boat was no longer there; it had been launched whilst I was not looking! Another time I was painting in a boatyard in Italy when there was a great commotion behind me. Forklift trucks were unloading steel girders with much banging and crashing, accompanied by much arm-waving and shouting from the foreman. I later learned that it had been intended to put this load right in front of where I was painting, but the foreman had insisted that this 'would disturb the painter'. Would this happen anywhere else in the world but Italy?

On a working slipway there is an abundance of activity, with figures bustling all around with hammers, planks and adzes. The part of the hull that is hidden when the craft is afloat is revealed in all its glorious shape. Colours of bare metal or gaudy undercoats abound. Red rust streaks, green seaweed and bright new wood all add pattern to the form of the craft.

On one occasion I was having great difficulty in attempting to mix the exact colour being applied to the hull of a boat by a 'real' painter. Then the solution dawned on me. Taking my palette over to where this other painter was working, I obtained a dollop of the actual colour; problem solved! Later, recalling this experience, I was

Opposite: The Beach at Dugeness. *Oil. 20 × 24 in./51 × 61 cm.*

Left: Fishing Boat Buckie. *Watercolour. 10 × 8 in./25 × 20 cm.*

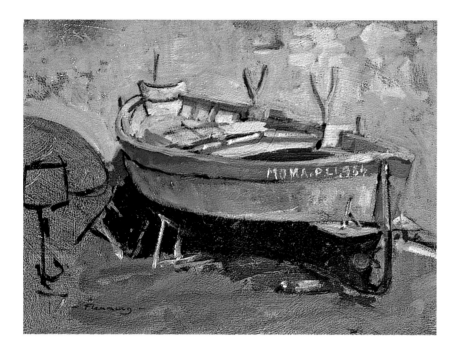

Above: Abandoned fishing boat, Giglio Campese.
Oil. 8 × 10 in./20 × 25 cm.

Above: Preliminary sketch for Hastings Beach. *Indian ink and wash.*
8 × 10 in./20 × 25 cm.

Opposte: Hastings Beach. *Oil. 24 × 36 in./61 × 91 cm.*

tutoring a group when the same colour-matching problem occurred. The problem here was with a dilapidated and abandoned craft with faded and peeling paintwork. My solution here was to suggest the students using watercolour made an attempt at the colour on a scrap of paper and took it up to the boat to see if it matched. Those using oil paint put a blob of their mix actually onto the boat. For the next hour it was amusing to see figures dashing back and forth between painting and boat.

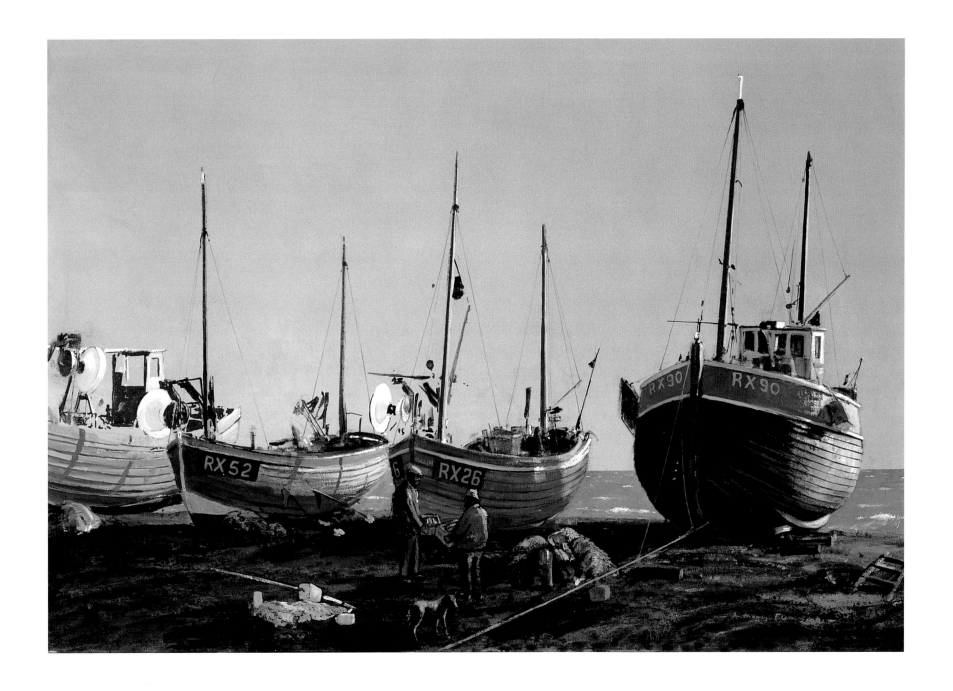

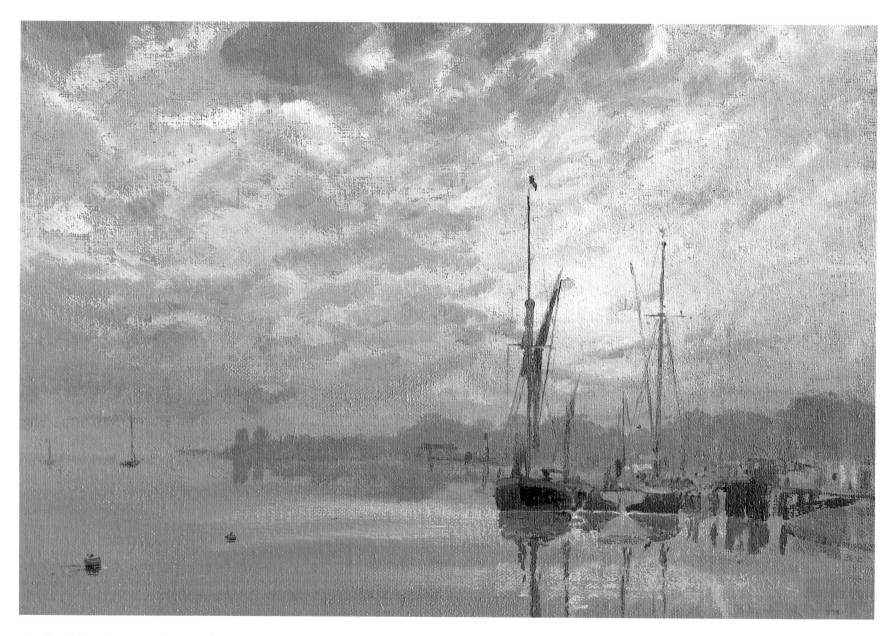

Evening Light, River Medway. *Oil. 20 x 30 in./51 x 76 cm.*

15. SKIES AND CLOUDS

Sky Sketch, Holland.
9 x 13 in./23 x 33 cm.

Clouds are never as white as you would imagine. Try holding a white sheet of paper up against the sky. You will see that, depending on the time of day, the apparently white cloud is creamy or pinkish. The sail of a yacht is far lighter than the clouds above it. This fact is another reason that I choose to start many of my paintings and sketches on a tinted ground, adding the white as body colour. I find it saves me a lot of time.

There are purists in watercolour who claim, according to their rules, that this approach is not authentic. I say that rules are there to be broken, especially if the results are more rapid and equally satisfying. On a visit to the Tate Gallery in London, I was gratified to see that Turner in his sketches of the Loire had adopted the very same approach, adding the lighter colours in body colour.

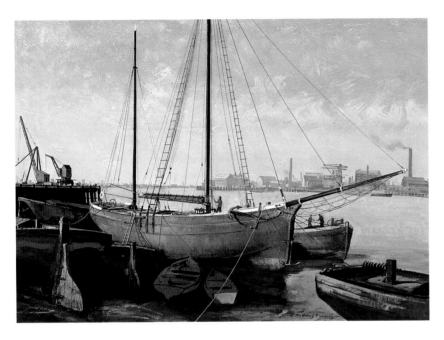

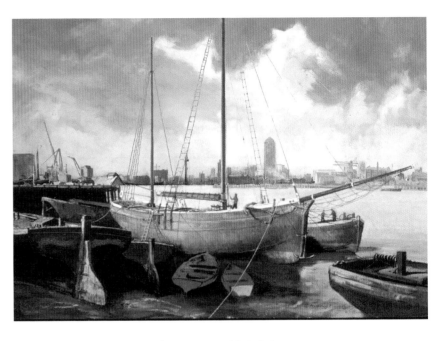

Low Tide, Greenwich. *Oil. 24 X 30 in./61 X 76 cm.*

Low Tide, Greenwich *(with computer-added sky).*

Skies provide a foil, as well as a background, to all manner of subject matter. It is worth considering how the manipulation of a sky can help or hinder a painting. Generally, a complicated foreground calls for a simple sky. Conversely, a simple foreground can be enhanced with a grand sky.

The sky, more than anything else, sets the mood of a painting.

In the second illustration above, the group of boats has been augmented by the electronic addition of a sky taken from another painting (with thanks to my neighbour Dennis for this manipulation). Note how the mood is changed, becoming more dramatic with the addition of a threatening sky.

There is a saying that goes, 'Paint a sky a day', but this is not always a practical thing to do. On days with a cloudless blue sky from

horizon to horizon this would become a somewhat pointless exercise. But on a changeable day, with clouds scudding across the firmament, one can make any number of sketches. On one particular day I made ten sky studies, one of which I have translated into oils. As yet I have not found the right subject matter to inhabit this setting. It sits on an easel in the corner of my studio beckoning me to come over and finish it.

Right: Dell Quarry. *Watercolour. 7 X 10 in./18 X 25 cm.*

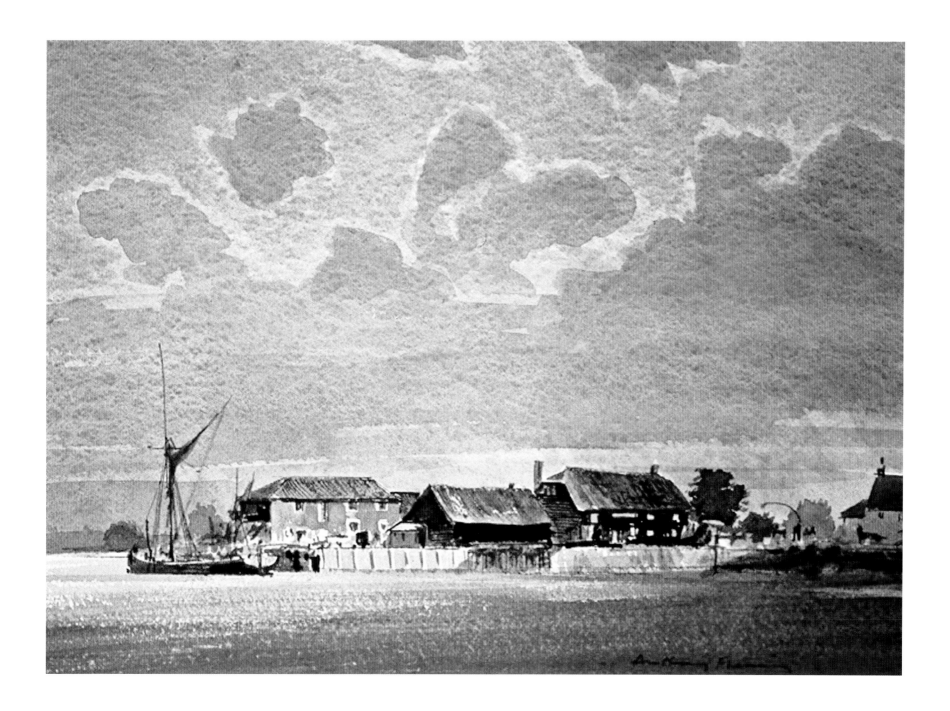

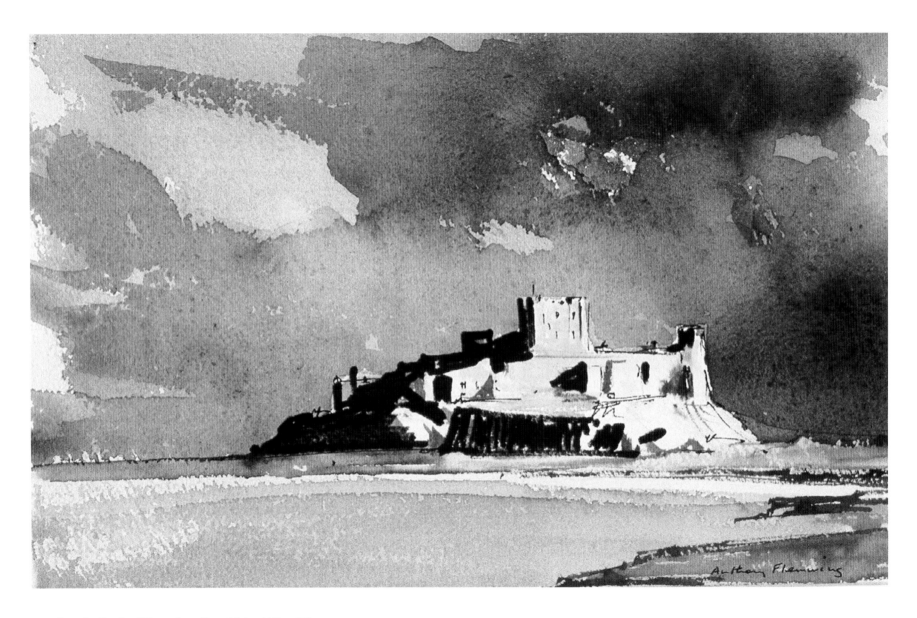

Bamburgh Castle. *Watercolour. 7 × 10 in./18 × 25 cm.*

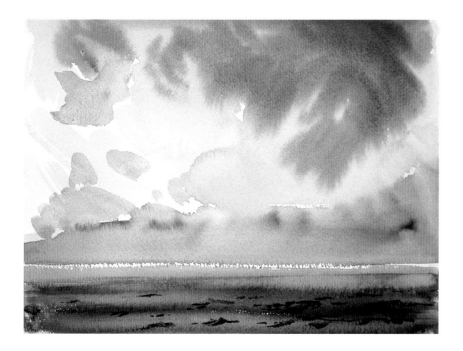

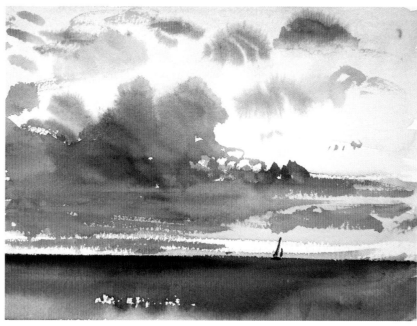

Sky sketches - note the gaps between sea and sky.

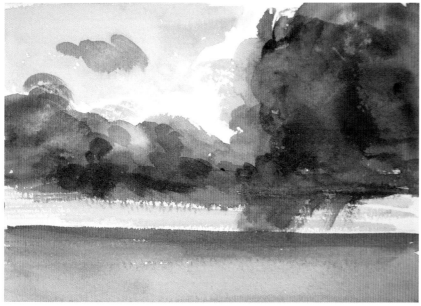

On this page is such a series of sketches, made aboard ship under sail. They attempt to capture the gathering stormy sky, progressing from threatening, through dramatic to calm. Each one took only about ten minutes. Only a few colours were used: raw sienna, yellow ochre, neutral tint, ultramarine and cadmium orange. In the final one cerulean blue replaced the ultramarine.

The technique used was wet-in-wet, with the colours flowing into each other. To avoid the sky flowing into the sea, a gap of dry paper was left between the two. There was no attempt made to produce a finished picture, but together that sky and sea have locked that glorious day into my mind.

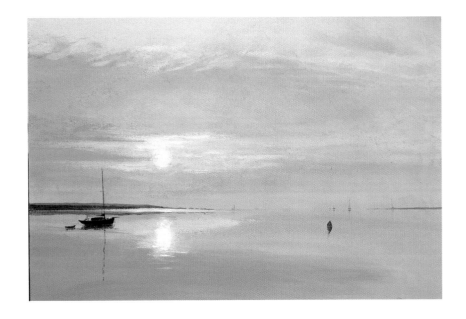

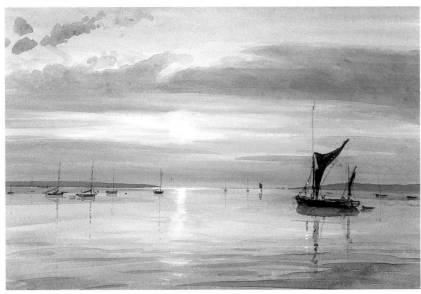

As a development from the sketches on the previous page, the sky in these three pictures is the major theme. Of course there are other elements included: reflections, not only of the boats, but of the sky itself; aerial perspective, in that the distant land is painted less darkly and with a bluish hue; and composition, in that the horizon is not midway up the paper, nor the sun or boat dead centre in the composition. In the last picture in this group, *Fish Market, Venice*, there is no sky at all. It was my intention to put one in, but, on viewing the painting in its mount, I thought it seemed OK without one.

Above, left: Sunset, Harty Ferry. *Watercolour. 8 × 10 in./20 × 25 cm.*

Above, right: Sunset, River Orwell. *Watercolour. 8 × 10 in./20 × 25 cm.*

Opposite: Fish Market, Venice. *Watercolour. 18 × 24 in./46 × 61 cm.*

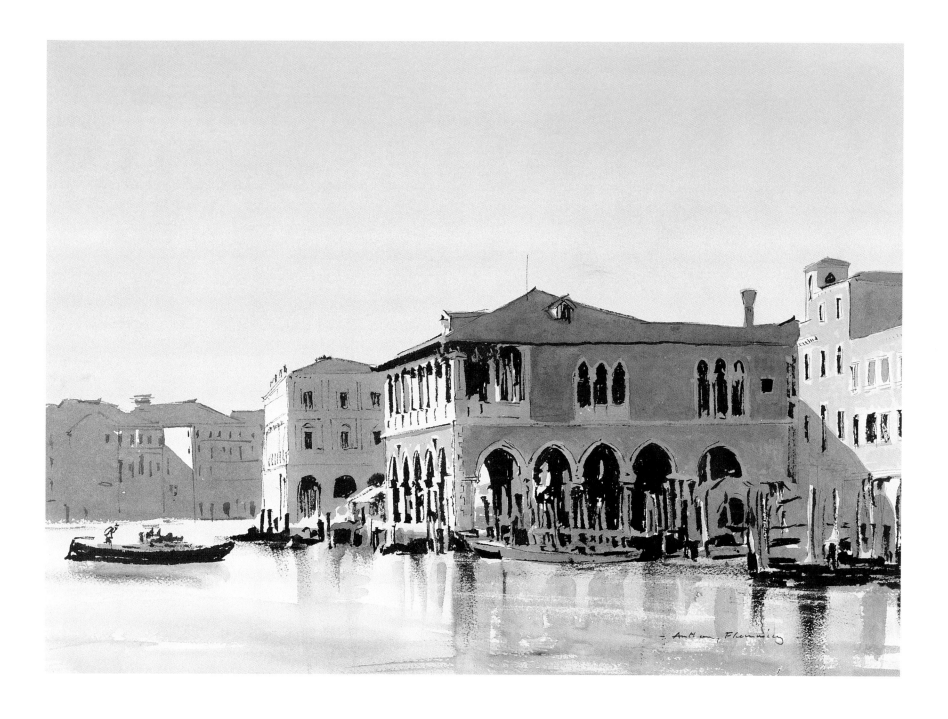

16. THE SEA AND ITS MOODS

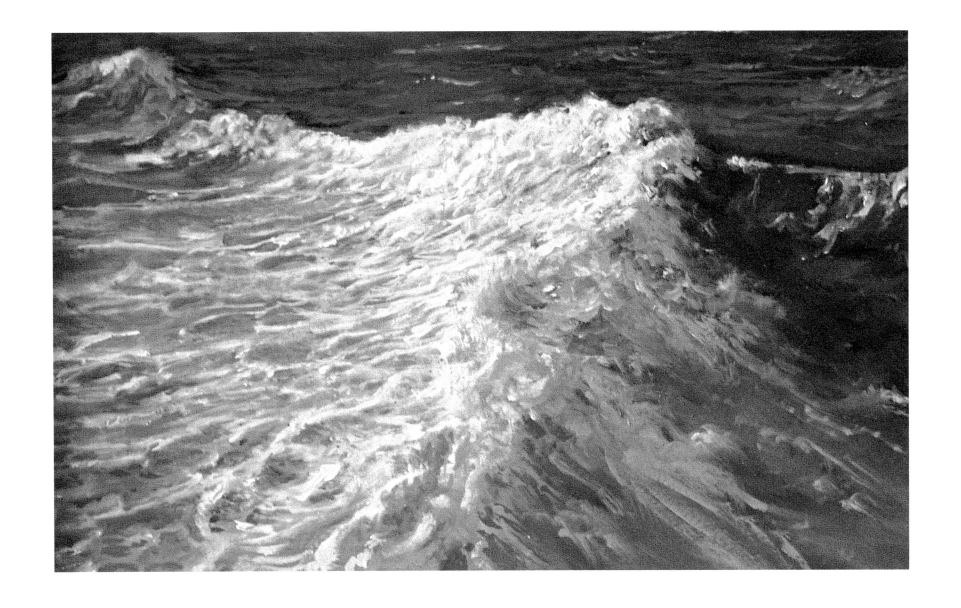

It is difficult to imagine that the sea is not a living thing. Seeing the ocean crashing against a rocky shore, it seems obvious to me that here is a force intent on pulverising the rocks into grains of sand; a force intent on reclaiming the land and imposing its will on a reluctant shore.

To scientists this view of the sea is poetic rubbish. In their eyes the sea is passive, content to lie smooth and even all over the globe. It is only the influence of the moon and the wind that gives any movement to this inert liquid. The moon, by exerting its gravitational pull, creates the rise and fall of the tides. The wind is the only mechanism that produces waves. Science explains that the wind rushing from high pressure to low pressure produces friction with the surface of water, thus generating waves. Sailors amongst you will know that gale warnings predict not only high winds but also high seas. Sailors too will know that wind against tide can produce unpleasant and often violent standing waves.

To the painter today, the scientific explanation may be accepted as fact, but the poetic effects of these ever-changing moods are a joy to

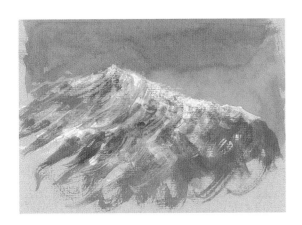
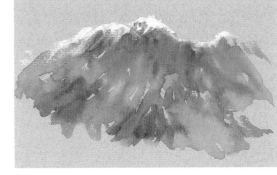
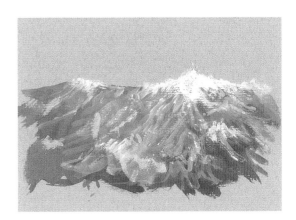

Five wave studies.

Opposite: The Wave. *Oil.*
16 X 24 in./41 X 61 cm.

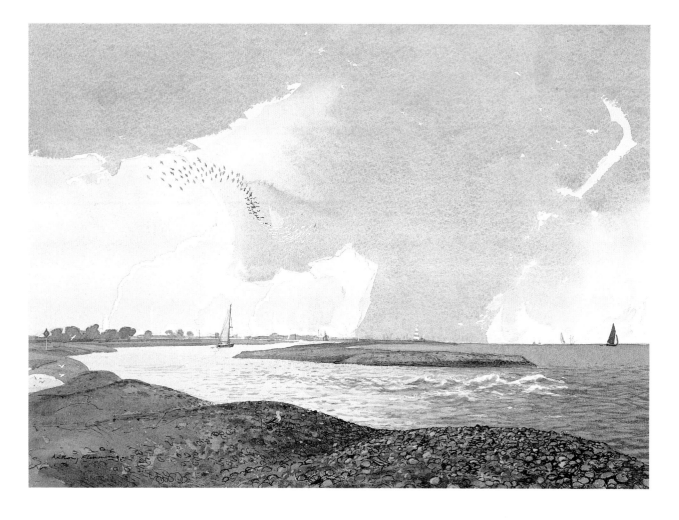

Left: Tide rip in the mouth of the River Orwell. *Watercolour.*
18 × 20 in./46 × 51 cm.

Opposite: French fishing boat on a choppy sea. *Oil.*
14 × 18 in./36 × 46 cm.

capture on paper. Tranquil reflections on a calm day make for a peaceful painting. Turbulent surf and white caps on a windy day can impart excitement and movement. The same scene may be captured time and time again in order to depict these changing moods of nature. The harbour wall might one day be crowded with fishermen casting their lines into a placid sea reflecting a clear blue sky. The very next day the waves might be crashing clear over the same harbour wall, with the clouds scudding across a stormy sky. I know that I must have twenty or so sketches made from the moorings of my boat, each one attempting to capture the new mood presented to me: one sketch, a pre-dawn calm; another, a shaft of light breaking through rain clouds. In every case the water plays its part in conveying the mood of the day.

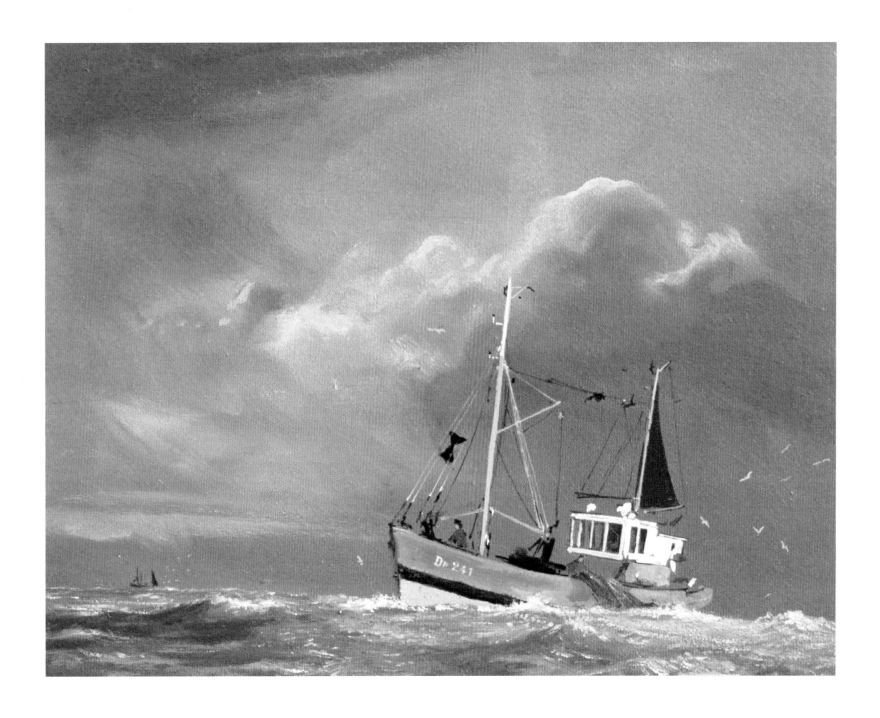

17. REFLECTIONS

On a perfectly calm sea the reflection of an object will exactly mirror that object. The reflection of a mast will appear to be the same distance down into the water as the height of the mast is above it. A light reflected would be a dot.

With a faint breeze the surface of the water will take on a slight undulation. The effect of this is slightly to distort the reflection. Reflections of masts and sails become wobbly but remain the same apparent depth into the water.

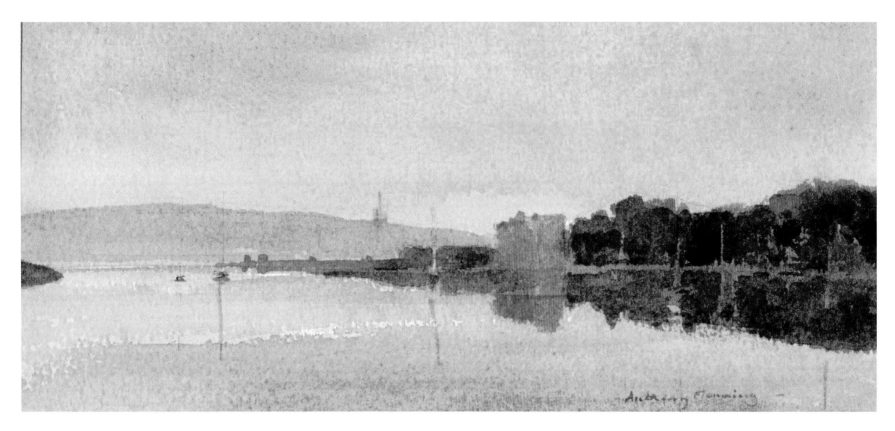

Upnor Castle at Dawn. *Watercolour. 6 X 10 in. / 15 X 25 cm.*

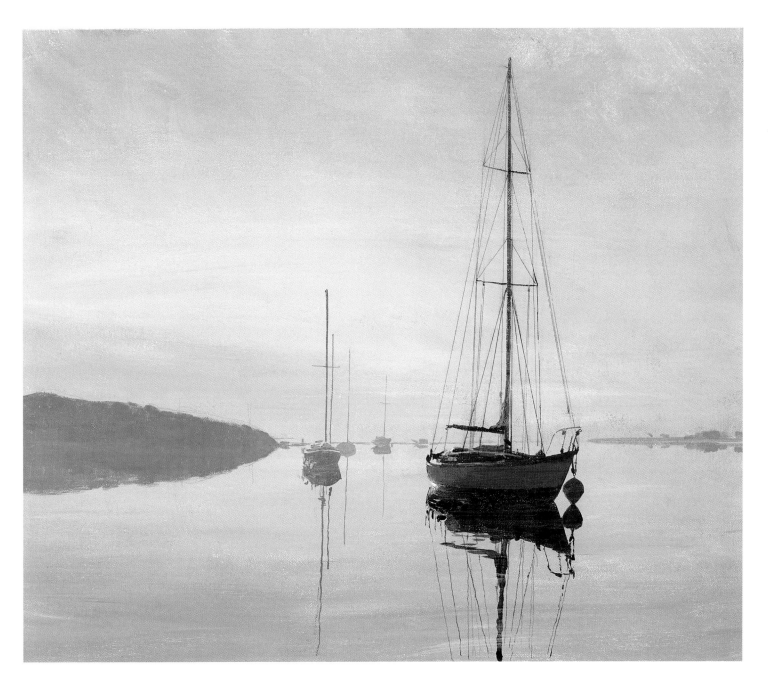

Calm Morning, River Medway. *Oil. 16 X 22 in. / 41 X 56 cm. Note the aerial perspective, with the more distant boats depicted fainter and in less detail.*

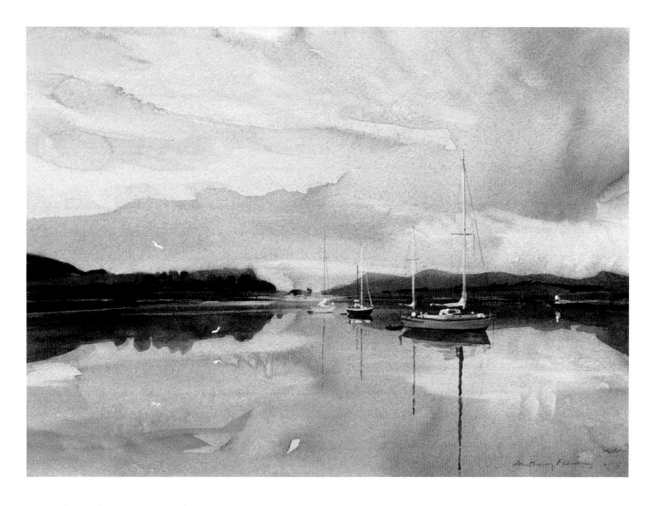

Scottish Anchorage. *Watercolour. 10 × 14 in./25 × 35 cm.*

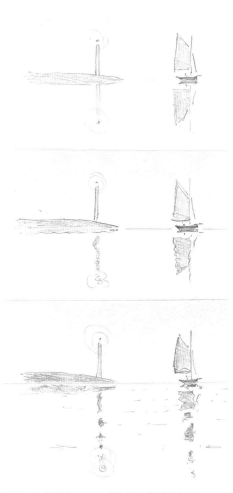

Above: Flat calm to light breeze.

Opposite: Weighing anchor at dawn.
Oil. 14 × 18 in./36 × 46 cm.

 With a bit more wind the effect on reflections becomes a bit more dramatic. The reflection of the same masts and sails becomes even wobblier, and towards the bottom of the reflection these objects become fragmented. Together with this fragmentation, the reflection also becomes longer, appearing to go deeper into the water. The relationship to this lengthening is proportional. As it were, the missing bits of the reflection are added to the overall apparent depth.

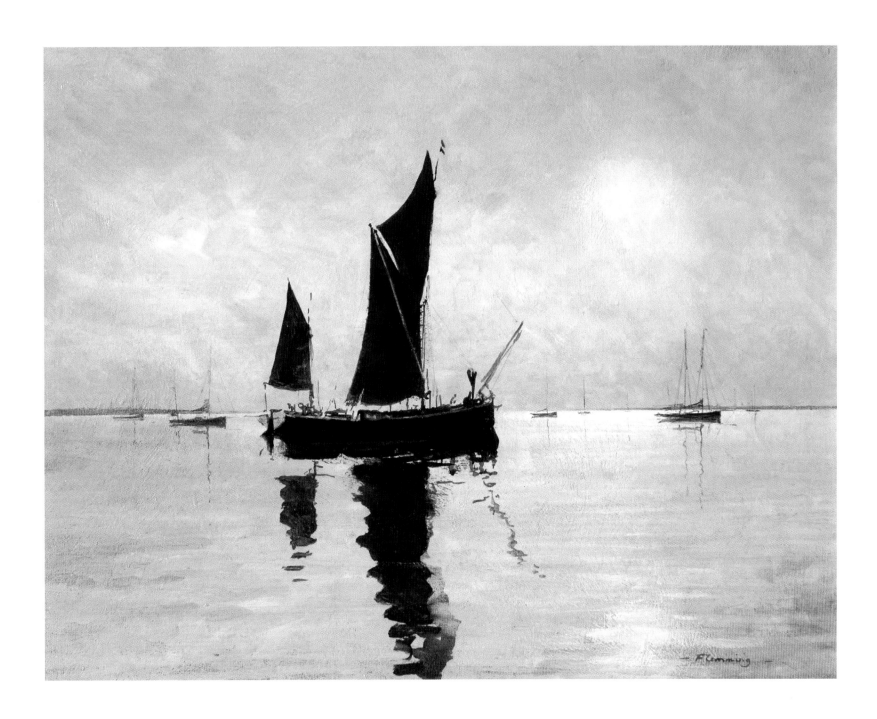

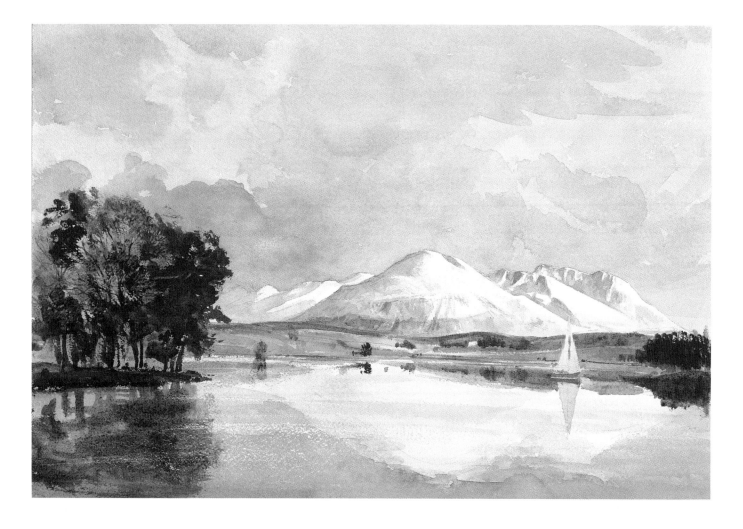

Ben Nevis from Loch
Lochy. *Watercolour.*
20 X 24 in. / 51 X 61 cm.

With increasing wind strength the fragmentation becomes more pronounced and the apparent length of reflection increases. This fragmentation is most clearly seen with the reflection of light. The light from a buoy becomes a series of dots, and the reflection of sun or moon becomes a path of light.

A further increase of wind speed, up to a breeze, will destroy reflections of craft and objects alike. The exception to this is the sun and moon. Because of their apparent relative size the reflections of their light will remain, even in a full gale.

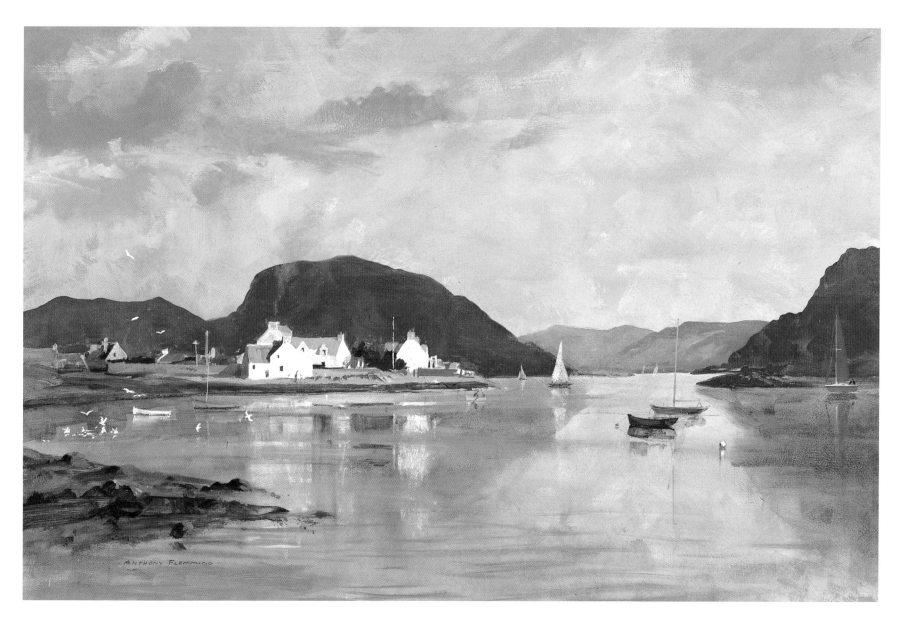

Plockton. *Oil. 18 × 20 in. / 46 × 51 cm.*

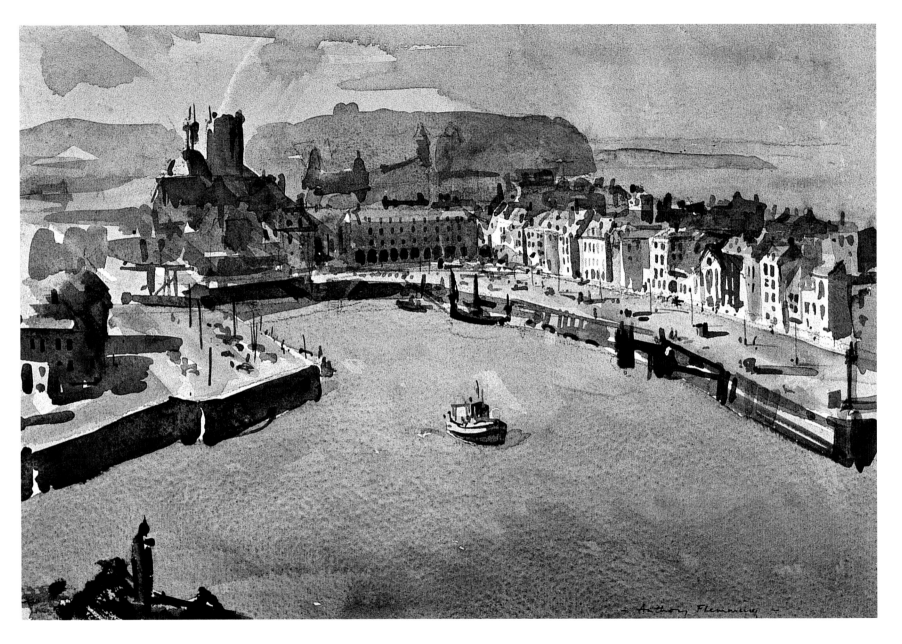

Dieppe Harbour. *Watercolour. 9 X 13 in./23 X 33 cm.*

18. HARBOURS: SETTING BOATS IN THEIR SURROUNDINGS

Smaller harbours worldwide have a unity of purpose. Examples that spring to mind include Whitby in Yorkshire, Istanbul in Turkey, Essaouira in Morocco and so many on the seaboard of the Americas. Larger harbours that have developed into ports may still contain corners that reveal their more humble origins. Smaller harbours and ports are usually more accessible to the painter. So often, part of a small harbour will be set aside for a fishing fleet. The similarities, yet subtle differences, between fishing boats throughout the world make these craft such wonderful subjects to paint.

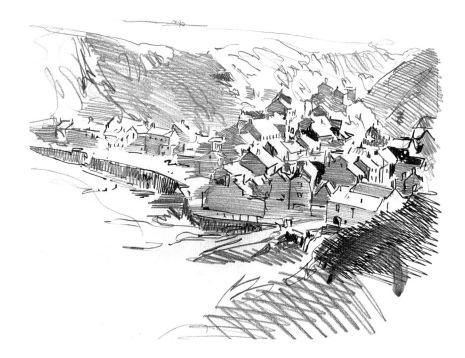

Staithes. *Pencil sketch.*

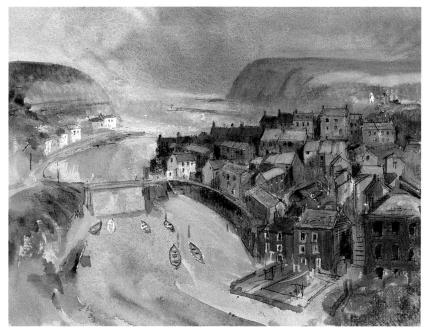

Staithes. *Watercolour. 11 × 14 in./46 × 61 cm.*

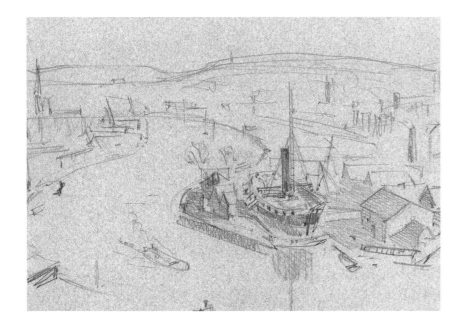

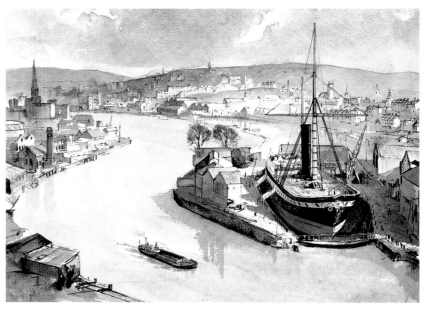

It is not only the boats that offer subjects for painting; discarded and rusting machinery, piles of nets and the bustle of figures attending to the maintenance of their craft and equipment can be equally compelling. Also in these harbours there will be a slip where boats are hauled out for cleaning, painting or repair. A slip is a great place to observe and capture the subtle shapes of a hull. Lastly, fishermen's houses and cottages huddled together as if for warmth are another possible subject for the adventurous painter.

Left: SS Great Britain at Bristol. *Pencil. 8 X 10 in./20 X 25 cm.*

Above: SS Great Britain at Bristol. *Watercolour. 15 X 23 in./38 X 58 cm.*

Opposite: Coaster at Lovells Wharf. *Watercolour. 14 X 18 in./35 X 45 cm.*

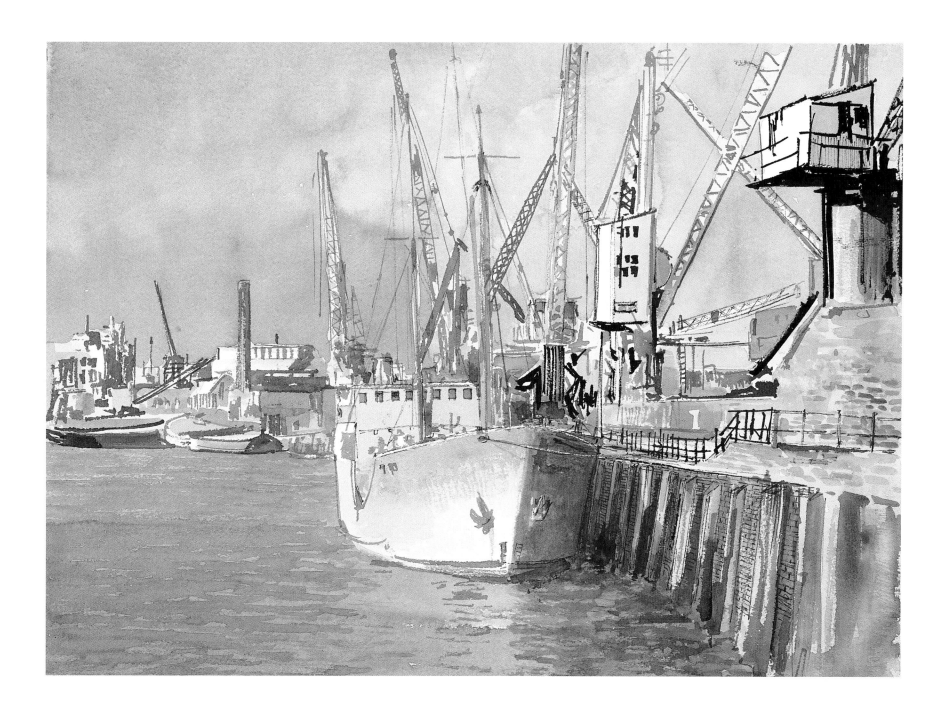

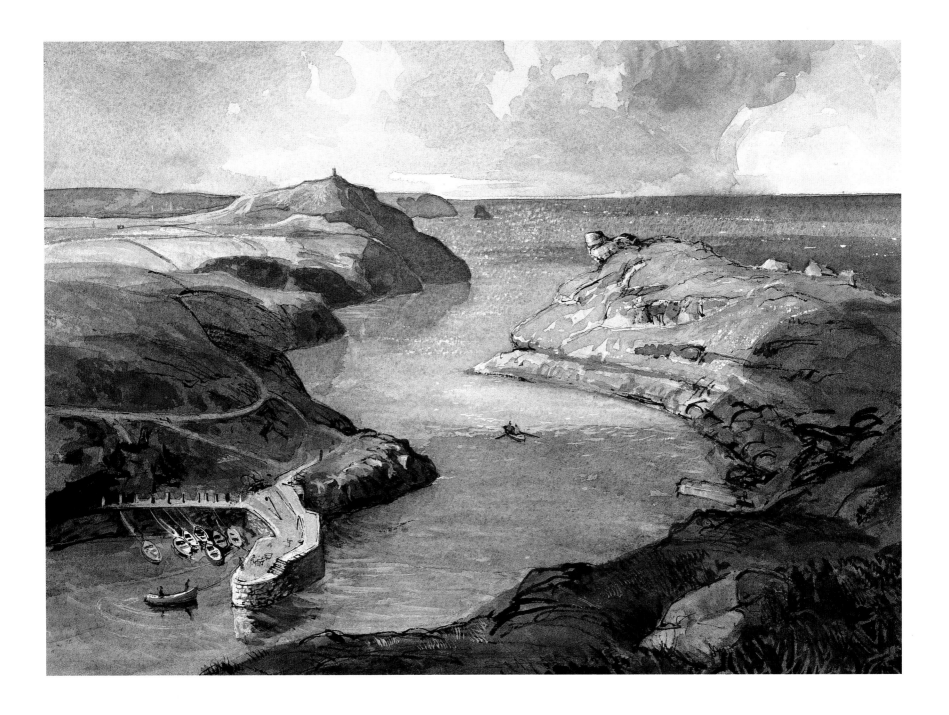

Opposite: Boscastle.
Watercolour.
12 × 15 in./
30 × 38 cm.

Right: Tobermory.
Oil. 10 × 12 in./
25 × 30 cm.

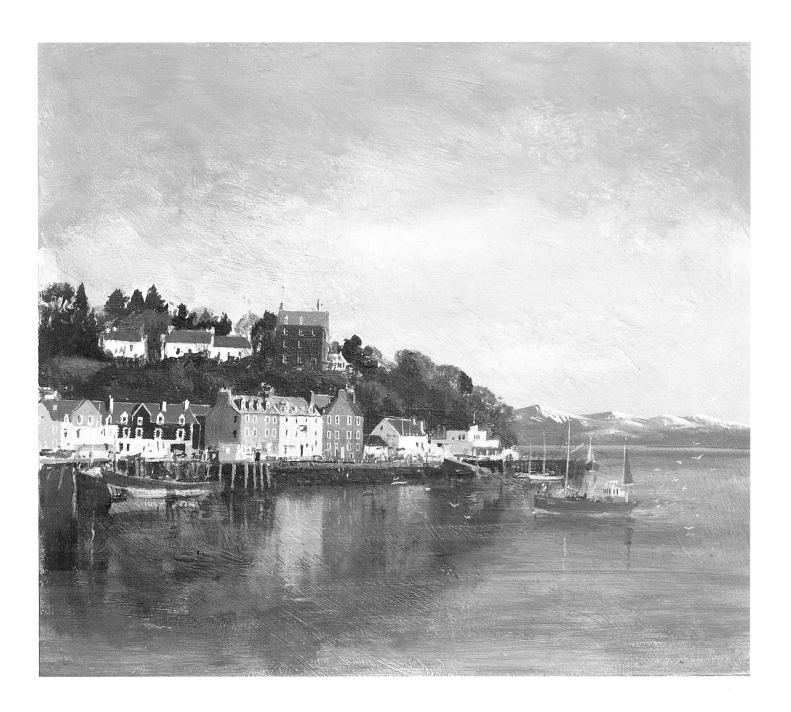

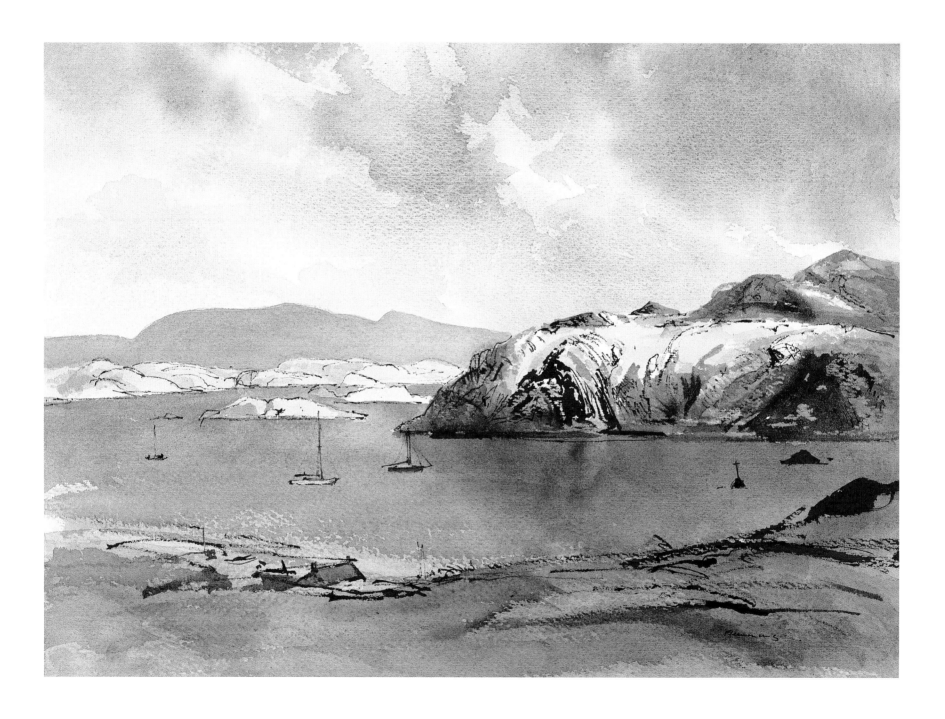

19. COASTS

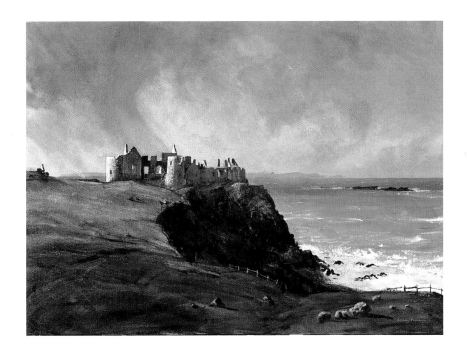

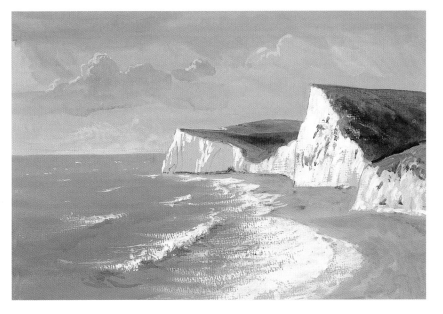

For the sailors amongst you, coasts are those bits on the chart that are tinted yellow – to be avoided with an onshore wind, especially those spiky bits! They are also, of course, places where you can find safe anchorages, pubs and restaurants.

For the rest of us the coast is often a place of recreation and relaxation. For the painter there is a special attraction: the interplay between the solid, the liquid and the gaseous. At the coast, the sea, land and sky provide an ever-changing environment for the painter to capture; be it a rugged headland with the sea boiling at its foot, or a marshy inlet with reeds and flocks of birds. Even on a crowded holiday beach there is a temptation to capture in paint groups of figures sunning themselves or sheltering from the wind.

The coast is a place where one sees the sky in all its glory, right down to the horizon. Sunrise and sunset offer further challenges. So be prepared, and never find yourself without a means of capturing the moment on paper.

Left, above: Dunluce Castle. *Watercolour. 12 X 15 in./30 X 38 cm.*

Left, below: Beachy Head. *Watercolour. 7 X 10 in./18 X 25 cm.*

Opposite: Scottish Anchorage. *Watercolour. 15 X 12 in./38 X 30 cm.*

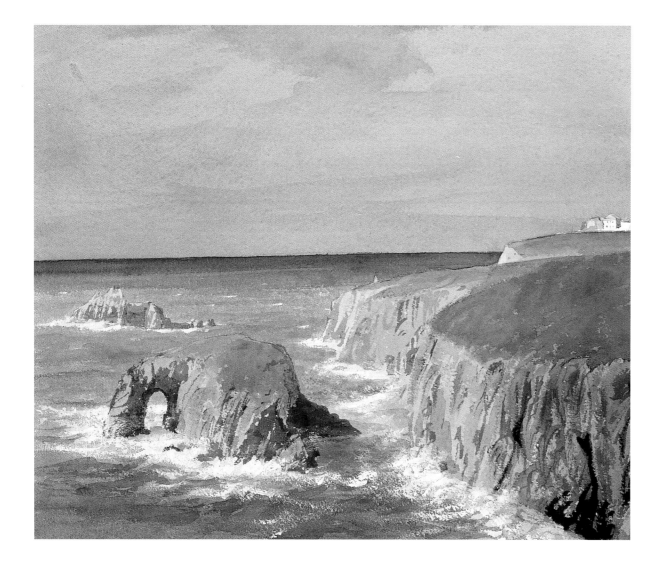

Left: Land's End. *Watercolour.*
12 X 14 in./30 X 35 cm.

Opposite: Lindisfarne. *Oil.*
20 X 30 in./51 X 76 cm.

The painting *Land's End* presented me with a few problems. On this exposed headland the wind constantly threatened to turn the painting into a kite. How I overcame this was to use my chair and easel as a windbreak. Crouching behind this assembly, with the board on the ground, I sketched in the composition lightly in pencil. Then I laid a wash of burnt sienna and yellow ochre over the areas of sky and land and part of the sea, leaving areas of white for the buildings and surf. Next I painted areas of grass using greens

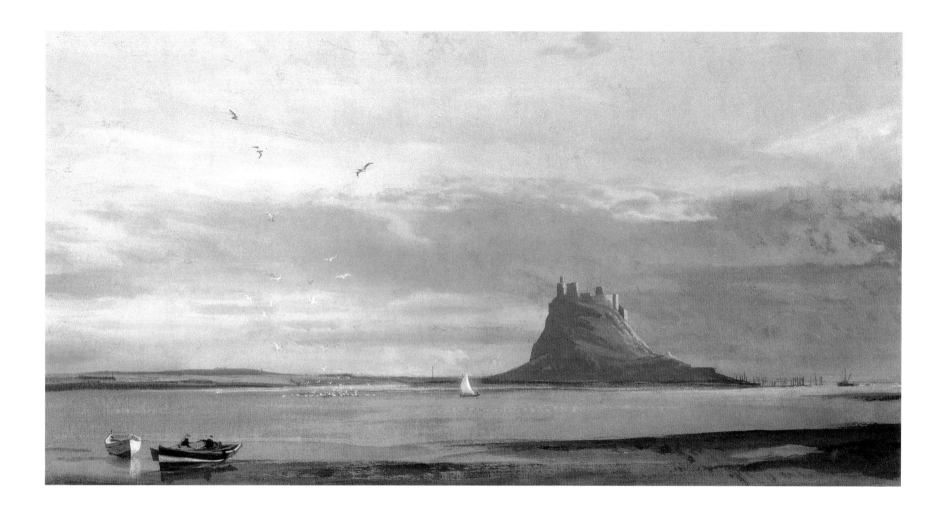

made from ultramarine, yellow ochre and cadmium yellow. Then came the sky using ultramarine moderated with neutral tint and a touch of alizarin crimson. While the sky was drying, I did some work on the cliffs using various colours, including burnt sienna and lampblack. The sea followed; in order to get the horizon straight I used low-tack masking tape. A mixture of ultramarine, lampblack and I think a bit of indigo was used here, with care taken to leave space for the main areas of surf. When this wash was dry, darker blue was further applied to the horizon and the foreground sea. That was enough; the wind had chilled me so that my fingers no longer wanted to work. At home in the studio I did a little more to the picture, adding body-colour white for the white caps and breaking surf, a little darkening to the foreground cliffs, and some detail to the buildings.

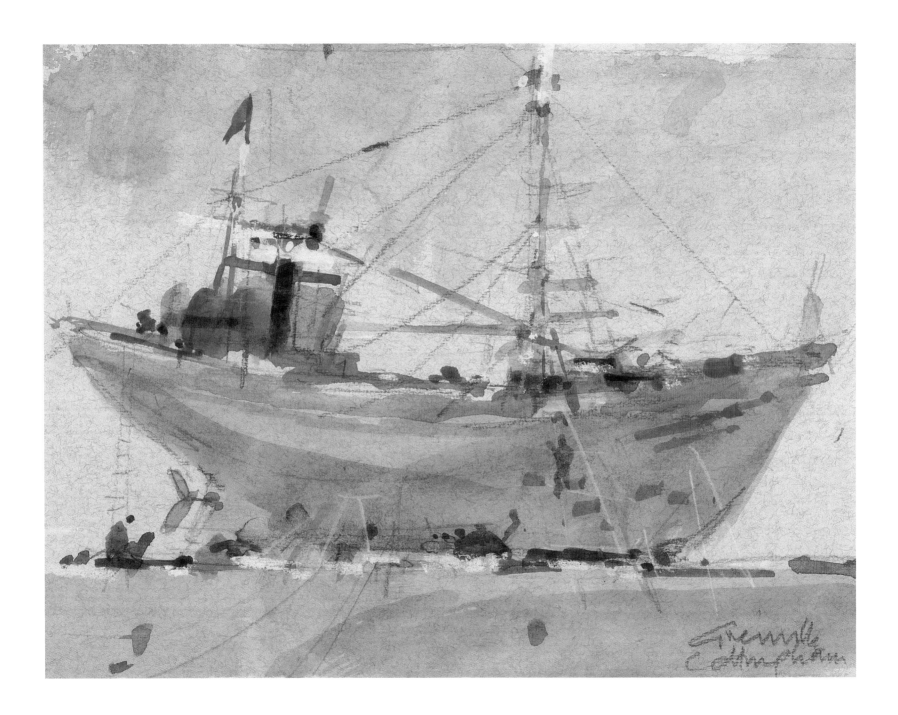

20. DRAWING WITH A BRUSH: NOT JUST FOR COLOURING IN

There is a joy and sense of freedom in drawing with a brush. To start with, a detailed line drawing will almost compel you to colour in up to the lines. To strike a shape directly in colour can be a liberating experience.

In the picture on the left, my friend Grenville Cottingham admirably demonstrates the excitement of drawing with a brush. Yes, there are a few faint pencil lines put down first – just enough to place the boat on the page. Using a pinkish paper, he boldly strikes in the essential shapes with a brush. The colours are initially limited to blue and brown; later, touches of red and black are added for emphasis. Finally, some drawing was added using brown and white chalk pencils.

This 'back to front' method of painting takes a little practice, but I think you will agree the results are worthwhile. Other instances of drawing with a brush are in the application of body colour and the blocking in of silhouettes. This technique, whilst not the norm in watercolour, is quite often used in oil painting.

Opposite: Fishing Boat, Essouria. *Watercolour. 7 × 9 in. / 18 × 23 cm.*

Right: The Helmsman. *Brush. 7 × 5 in. / 18 × 13 cm.*

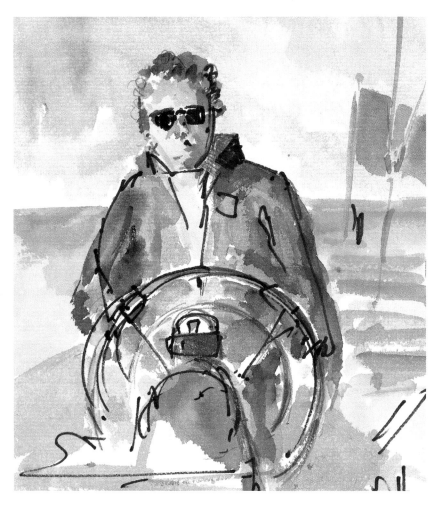

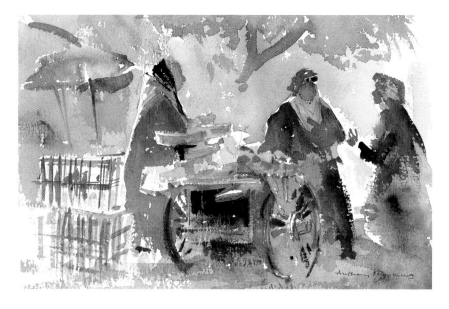

Above: Fish Market, Cairo.
*Watercolour. 8 × 10 in. / 20 ×
30 cm.*

Right: Fish Market, Cairo.
Detail.

Above: John at the Helm of Crusader.
Pen and wash. 8 × 10 in. / 20 × 25 cm.

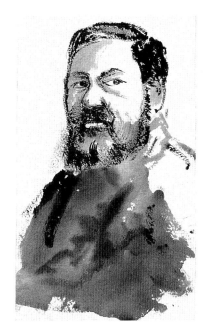

Left: Benny.

Right: Boats, Enkhuizen.

Below: Waterfront, Dieppe.

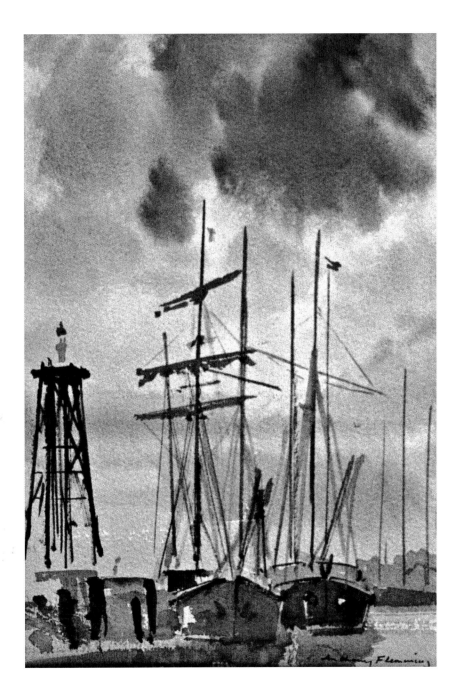

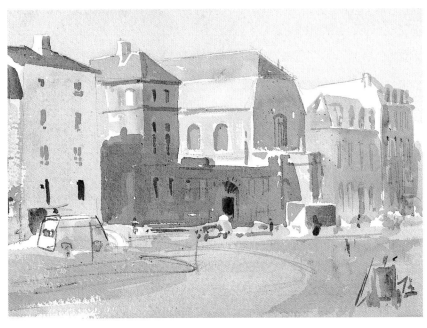

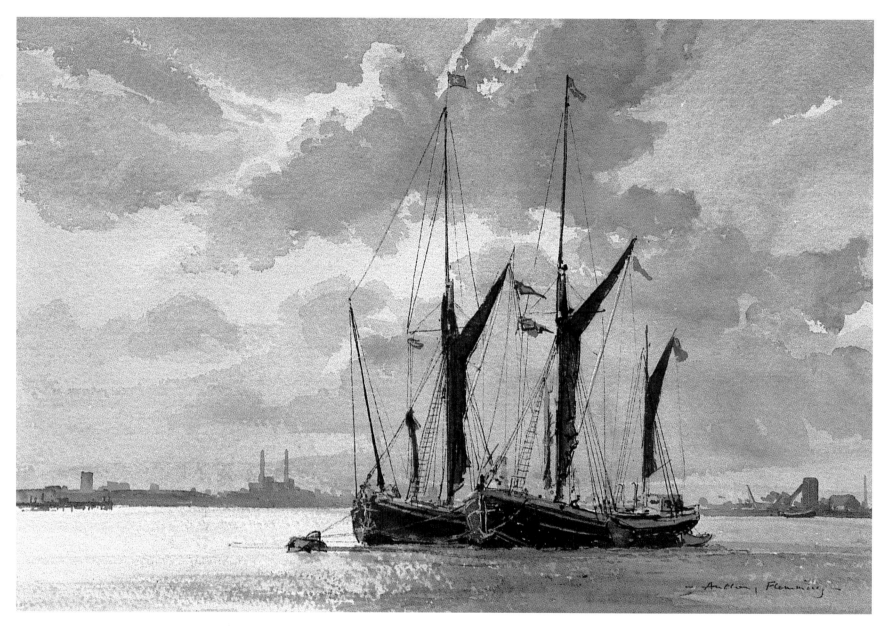

Thames Barges on a Mooring. *Watercolour. 9 X 12 in./23 X 30 cm.*

21. SILHOUETTES

The word 'silhouette' is usually associated with the black-on-white profiles of faces. However, they occur naturally in many things we see. Sails and rigging against the light often appear so dark as to be almost black. When painting such a view, block in these shapes with black or dark brown and the contrast with lighter areas of the picture will be dramatic. Here, drawing with a brush is a good way of achieving the desired effect.

The lack of detail in a silhouette leaves the viewer to fill this in for himself and saves the painter some effort. But, note that the more distant these shapes are the less bold they should be made. Distant vessels or buildings, whilst still silhouettes, should be treated in a softer tone. See Chapter 11, p.42, 'Aerial perspective'.

Silhouette. *Watercolour.*
5 X 10 in. / 13 X 26 cm.

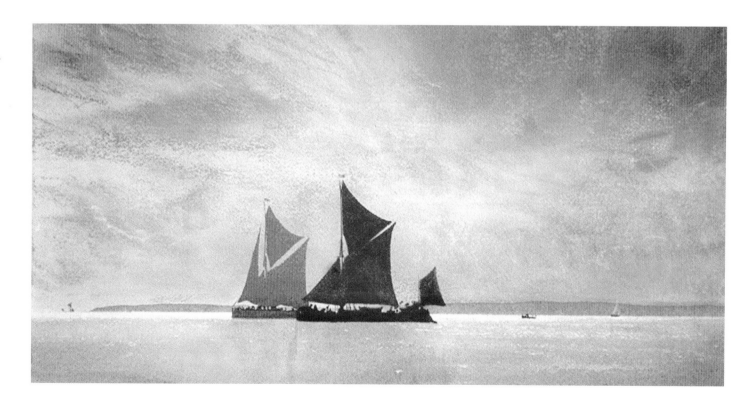

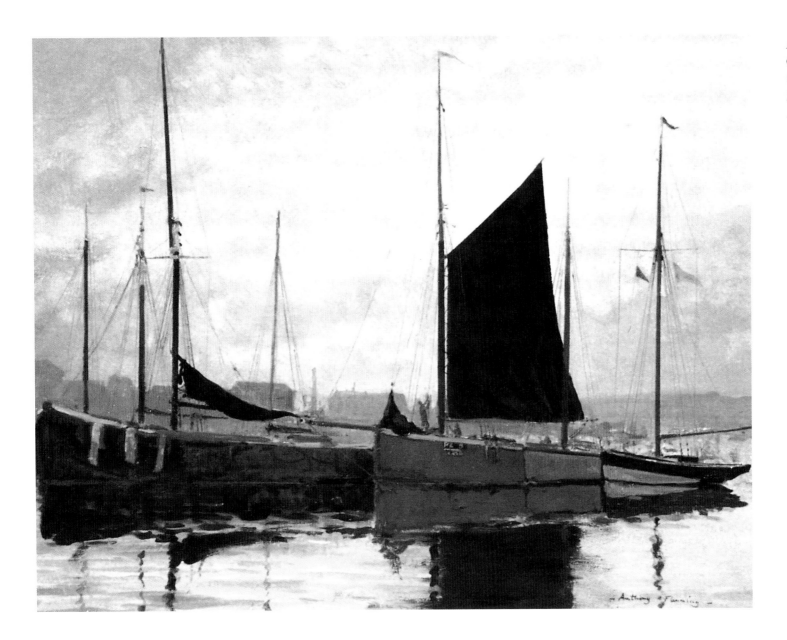

After the Match,
Queenborough.
Oil.
20 x 24 in./
51 x 61 cm.

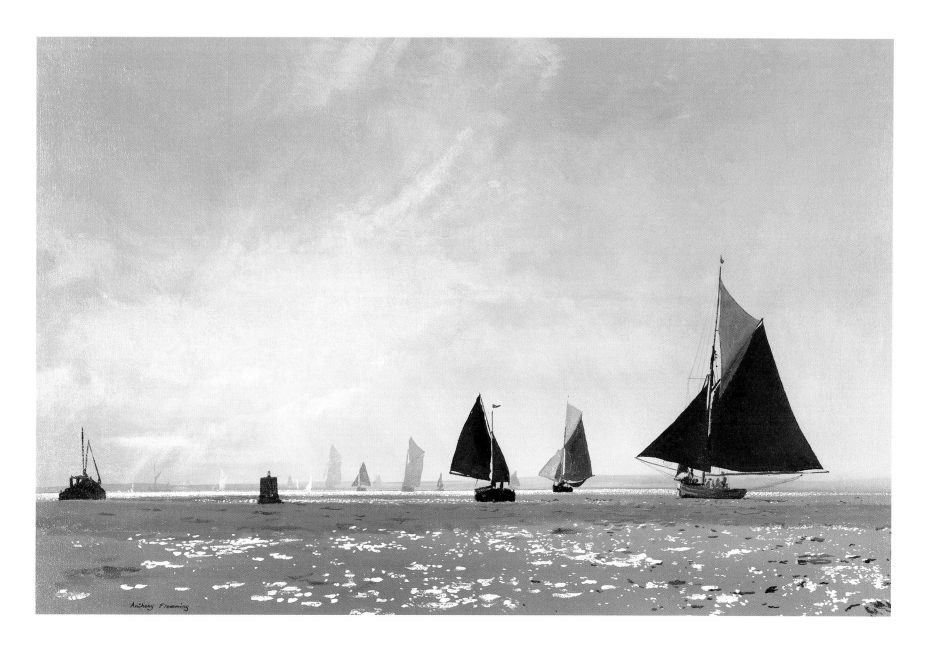

Running for Home, Swale Barge Match. *Oil. 20 × 30 in./51 × 76 cm.*

22. PEOPLE: CAPTURE AND INSERT

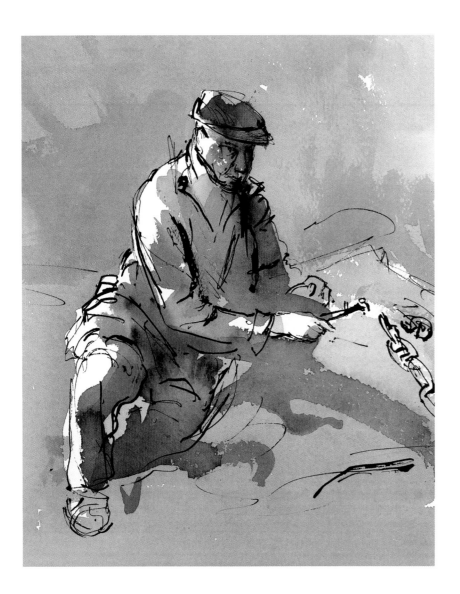

Master Shipwright. *Pen and wash. 8 X 6 in./20 X 15 cm.*

There is nothing quite like figures to enliven a painting. They add scale, movement and interest. It is surprising how often I can start a picture on the spot with no people in sight. Then along comes a man with a hammer to begin work over there.

In the picture opposite just such a thing occurred. In the painting there appear to be two men at work, but in fact it is the same person in two positions. These figures were caught in my sketchbook and included in the final studio painting.

There may not be a figure in the area you are painting, but can you include one? Try moving that person on the right of the scene.

On board ship, unless you are a single-handed yachtsman, the interesting shapes of the people running the ship can be compelling. The helmsman tends to be a splendid captive model, unselfconscious and usually alert.

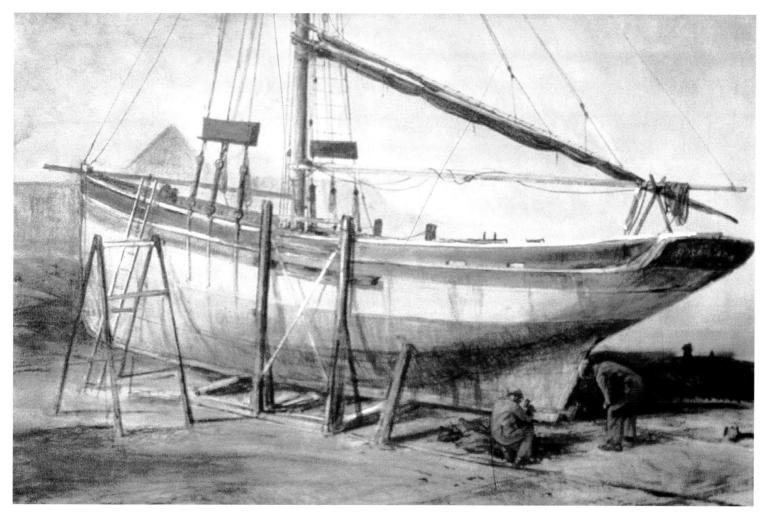

Rosa and Ada on the Slip *(see also sketch on p.49)*. *Oil. 24 x 30 in./61 x 76 cm.*

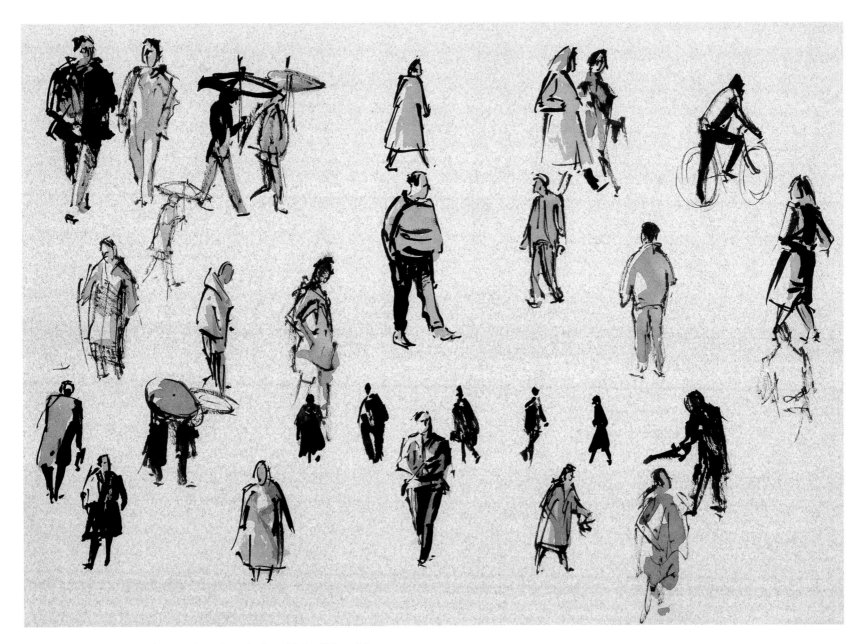

Figures on the Quayside. *Brush and wash. 8 × 10 in./20 × 25 cm.*

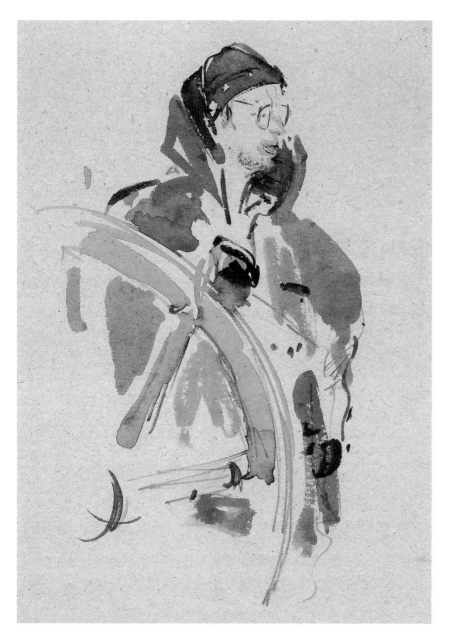

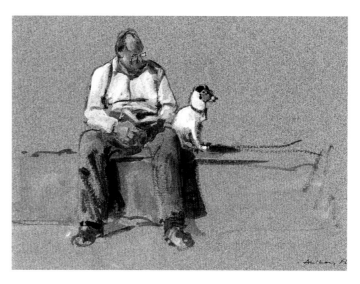

I'd Rather Be Chasing Seagulls. *Watercolour and bodycolour. 6 × 5 in./15 × 13 cm.*

A Cold Watch. *Drybrush and wash. 8 × 6 in./20 × 15 cm.*

Figures, Dieppe. *Pencil.*

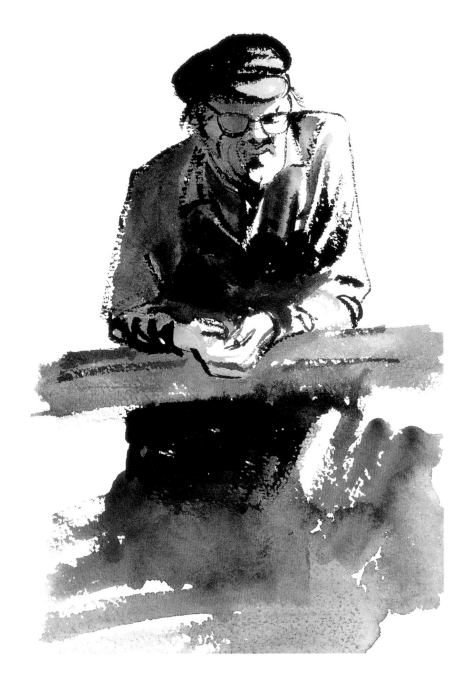

Left: Keeping an Eye on Them. *Dry brush and wash. 8 × 5 in./20 × 13 cm.*

Above: Grenville Painting. *Pen and wash. 5 × 4 in./13 × 10 cm.*

Opposite: Navigating Vic up the Thames. *Pen and wash. 6 × 8 in./15 × 20 cm.*

23. CHEATING: MAKING THINGS EASIER

There is a saying, 'All is fair in love and war.' I would add 'painting'. All is fair in love, war and painting. The end justifies the means. If the finished picture is right, how you got there is of little importance. If you had to capture that group of figures using curry powder on the tablecloth, then fine. In my opinion, that is not cheating. Some consider the use of photographs the height of cheating. Not me.

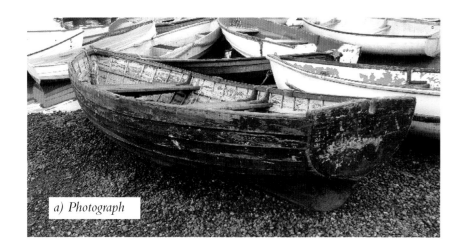

a) Photograph

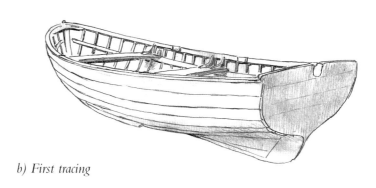

b) First tracing

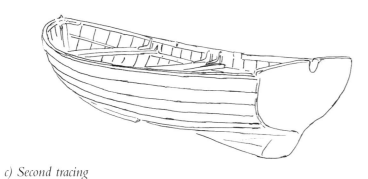

c) Second tracing

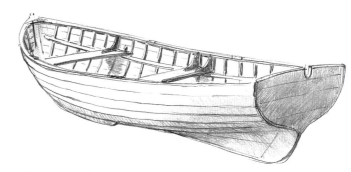

d) Freehand copy of second tracing.

But, beware. As I have mentioned elsewhere, a camera is a dumb animal; it cannot do what the discerning eye can do, namely, leave things out. All those unwanted and distracting features, which if you were sketching the subject would be discarded, are still there in intimate detail. Also, in a photograph the colours are so often far too bright.

I find photographs useful, but to a limited extent. They are useful to confirm how many windows there are in a particular building; where all those strings go on that mast. A photo will capture the subtle shape of a boat, or the fleeting shape of a cloud. But there are pitfalls too. It is all too easy merely to copy what the photo sets in front of you: a glimpse frozen in time. All too often one sees that a painting is merely a slavish copy of a photograph. The colours are as the camera saw them, not the artist. Water is a particular giveaway in this respect.

Nevertheless, the following exercise may help those who just cannot seem to capture the subtle shape of, in this instance, a boat: from a photograph, trace the boat; then trace that tracing; then attempt to copy that tracing freehand.

Use long sweeping lines. If you miss the shape, put in another where you see it should be. Don't bother to rub out any wrong lines; just emphasise the better ones. Tracing a photograph can be achieved by securing it with tape on a window, against the light. Stick a sheet of thin paper over the photo and proceed to make your tracing.

Sketches or studies such as those above can be photocopied, and washes can be experimentally applied to these without the risk of ruining the originals. Photocopies can also be made of a number of sketches and cut up and arranged experimentally in search of a composition. Vary the size of these copies and the results may be intriguing and instructive.

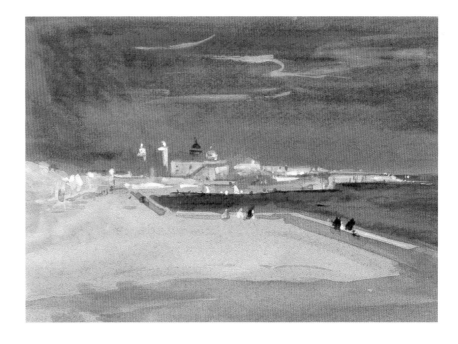

Above: Tribute to HBB.

Another exercise that some might consider cheating is to copy the work of another artist. As long as the result is not passed off as your original work, there is much to be learned in such a practice. In the painting above I show my copy of a picture by the artist with the splendid name of Hercules Brabazon Brabazon. The thing that attracted me to this exercise was the simplicity of treatment. Made on tinted paper, the forms are indicated with such economy of means. The use of white, both on its own and mixed with watercolour, was a revelation to me.

24. PITFALLS: THINGS TO AVOID

When painting or sketching outdoors it is tempting to feel obliged to put down all that is in front of you. Well, artists have a great advantage over the photographer: we can simply leave things out. Eyesores too can be eliminated. Parking signs, directions to urinals and other distracting elements vanish from our painting. More than that, we can add things. That blank space in the foreground can be filled with that bollard over there in the middle distance. A coil of rope or a sleeping dog, sketched previously, can be inserted to taste.

One thing I have learned over the years is to avoid thinking I can paint the same view for a whole day. In the morning, buildings or trees will be lit from one direction. Come the afternoon it is more than likely they will be lit from the opposite direction. If you like the subject and have the time available, make two pictures: one morning, one afternoon.

With marine subjects, more than landscapes, things will change unexpectedly; sometimes this will be to your advantage, but, perversely, it is usually the opposite. For example, you may be painting a harbour with a splendid barge moored against the quay when in comes the tide and the barge promptly sets sail! This kind of situation is why I advocate making a quick pencil sketch first, so as to grab the essentials. This will freeze the subject and in addition will help appraise the composition.

In the sketch above I have roughly captured the whole panorama that presented itself to me. The thing that became obvious to me by doing such a sketch was that to attempt to paint the whole scene would take an age. So with a couple of sheets of paper I masked the sketch, deciding that just a portion of it would be a more manageable, and also better, composition.

I have found that even when I have not been able to undertake the intended picture, as in the case above, the quick sketch recalls the view with surprising clarity. The point is to be selective; do not bite off more than you can chew.

Should you wish to add a sail to enliven your picture, avoid the pitfall of having wind or sunlight coming from different directions. Ensure that the sail is set to fill in the same direction as the wind on the sea. A sailing boat will look odd if close-hauled whilst sailing in a following sea. Flags too look better flying in the correct wind direction.

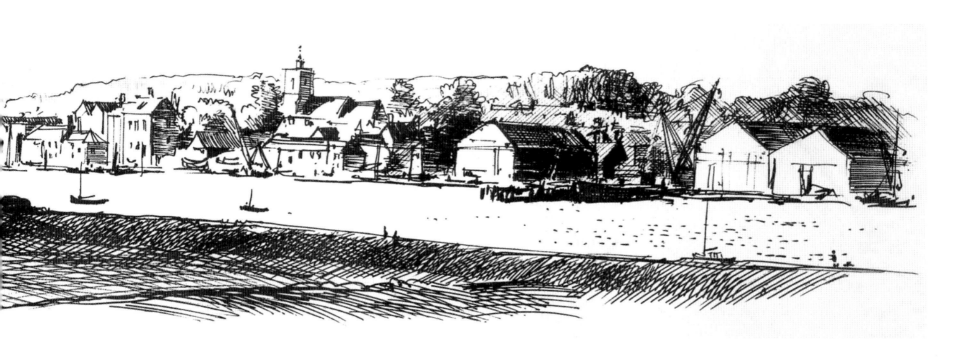

Above: Panorama. *Pen. 10 × 3 in./25 × 8 cm.*

Left: Detail of Panorama.

25. LEARN BY YOUR MISTAKES

It seems that only by making mistakes can you actually learn anything in painting. You hear advice and are given rules, but it is only really when you have made the blunder for yourself that it actually sinks in. The main thing is to recognise the error, have a laugh at yourself and promise not to do it again.

Time after time I have broken my own rules, put too much in or painted things in the wrong order. One of the rules I have given myself is to paint the background first and progressively work towards the foreground. Clearly it would be difficult, if not foolish, to paint a tree and then attempt to paint the sky between the branches.

The image on this page is a clear example of me ignoring my own advice. The group of barges was painted on the spot, far away from St Paul's. I recall that the background was uninteresting and confusing, so I left it out. Some time previously I had made a sketch of St Paul's from across the river, where the foreground was very dull, so I left that out. Later, in the studio, I decided to combine the two and put the background behind the foreground. This was quite time-consuming, but at least I did follow my other rule of making the distance less dense than the foreground. (See the 'Aerial Perspective' chapter, p.42.)

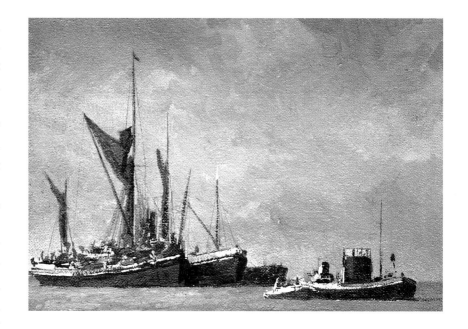

Above: Moored Thames Barges. *Oil. 20 X 24 in./51 X 61 cm.*

Opposite: St Pauls.

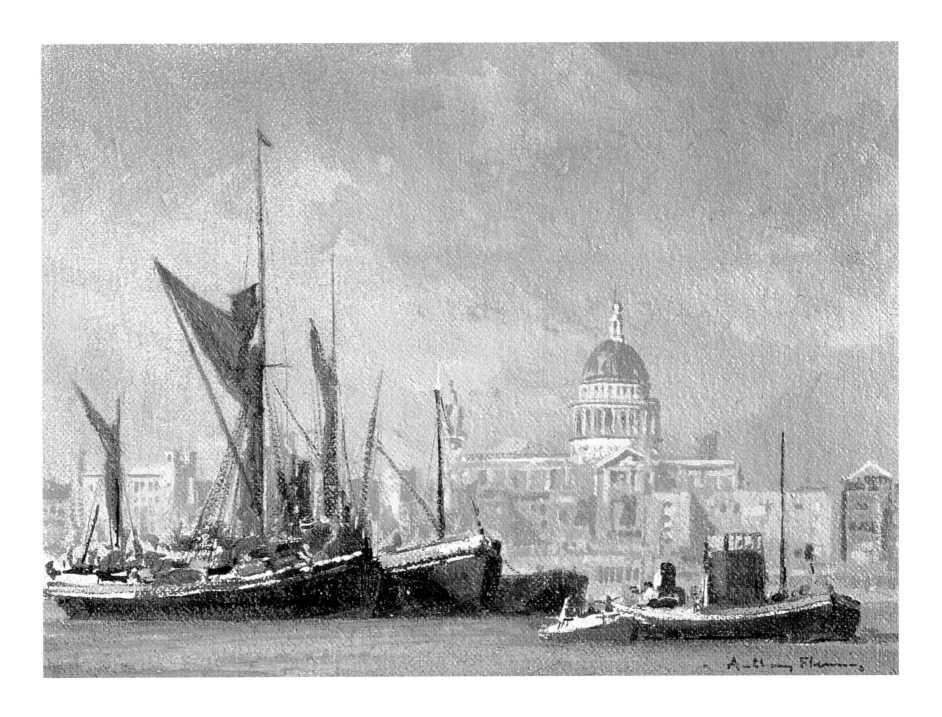

CONCLUSION

It is my sincere hope that in this book I have been able to convey my enthusiasm for the subject of painting boats and their surroundings. More importantly I hope that some of that enthusiasm will have rubbed off on you, the reader.

I would especially hope that the sailors amongst you, with your privileged viewpoints, will have a go at capturing on paper a glimpse of what surrounds you. Historically sailors have augmented their logbooks with sketches of landfalls, headlands and hazards. Continue and expand this noble tradition. Capture harbours, interesting anchorages, majestic skies and perhaps your fellow crewmembers.

To the painters amongst you I hope that I have been able to remove some of the mystery of all those bits of string and cloth that adorn sailing craft. My palette may be different to yours, but if I have opened your eyes a little to the subject then I rejoice.

Above all, be you sailor or painter, enjoy. Put down that camera and take up the brush.

Anthony Fleming, Spring 2006.

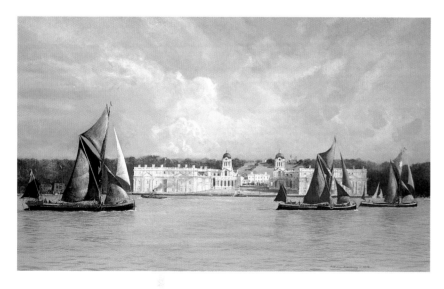

Royal Naval College, Greenwich. *Oil. 4 x 8 ft./1.2 x 2.4 m.*

They Never Stay Still. *Pen.*